SPEAKING THROUGH MEMORY

二埠 Yi Fao

SPEAKING THROUGH MEMORY

A History of New Westminster's Chinese Community 1858-1980

JIM WOLF *and* **PATRICIA OWEN**

VICTORIA · VANCOUVER · CALGARY

Copyright 2008 © New Westminster Museum and Archives

First edition

Heritage House Publishing Company Ltd.
#108 – 17665 66A Avenue
Surrey, BC V3S 2A7
www.heritagehouse.ca

Heritage House Publishing Company Ltd.
PO Box 468
Custer, WA
98240-0468

Library and Archives Canada Cataloguing in Publication
Wolf, Jim
 Yi Fao: speaking through memory: a history of New Westminster's
Chinese community, 1858–1980 / Jim Wolf and Patricia Owen.

Includes bibliographical references.
ISBN 978-1-894974-40-0

 1. Chinese Canadians—British Columbia—New Westminster—History.
2. Chinese Canadians—British Columbia—New Westminster—Biography.
3. New Westminster (B.C.)—History. 4. New Westminster (B.C.)—Biography.
I. Owen, Patricia, 1978– II. Title. III. Title: History of New Westminster's
Chinese community, 1858–1980.
FC3849.N49Z7 2008 971.1'33 C2008-902737-X

Library of Congress Control Number: 2008921330

Cover and book design by Roberta Batchelor

Cover photograph: George Quan, Winston Quan and Benny Quan riding west along Royal Avenue, 1942; photo courtesy of George Quan.

Printed in Canada

Heritage House acknowledges the financial support for its publishing program from the Government of Canada through the Book Publishing Industry Development Program (BPIDP), Canada Council for the Arts, and the province of British Columbia through the British Columbia Arts Council and the Book Publishing Tax Credit.

The Canada Council | Le Conseil des Arts
for the Arts | du Canada

BRITISH COLUMBIA
ARTS COUNCIL
Supported by the Province of British Columbia

❦ DEDICATION ❦

For Fannie Lee and all of the memories she possessed; she was our last link to the heart of Yi Fao. To Chung Koo for providing us with his "memory maps" and the opportunity to visit and visualize a moment gone by. Finally, to all the community members who spoke through memory of their lives and the lives of those who have passed. Collectively they gave voice to Yi Fao, its creation and its endurance.

❦ ACKNOWLEDGEMENTS ❦

This book began as a result of the exhibit Yi Fao—Speaking Through Memory, held at the New Westminster Museum and Archives in 2007 and jointly curated by Patricia Owen and archivist Kelly Stewart.

The exhibit and book would not have been possible without the ongoing financial support and encouragement of New Westminster City Council and the support of the citizens of the Royal City, who have shown great interest in Yi Fao and the special place that the Chinese-Canadian community holds in our history.

The authors thank museum manager Colin Stevens and all of the staff and volunteers for their assistance in bringing the story of New Westminster's Chinese community to life. Special thanks to Jason Haight, business operation manager of the New Westminster Parks and Recreation Department, for guiding this project to completion. The staff of the New Westminster Public Library reference department, including Anne Lunghamer, Wendy Turnbull and Sunday Scaiano, provided scans of historic photographs. Thanks also to Rod Nevison for his assistance in creating the maps of Chinatown.

Finally, the project would not have been possible without the truly remarkable families of Yi Fao who shared their memories with us. We are honoured that they entrusted us with their stories to allow Yi Fao to "speak through memory."

❧ CONTENTS ❧

Introduction II

A History of Yi Fao, by Jim Wolf

 Gold Mountain {1858-1880} 13

 A Little Bit of Old China {1881-1887} 17

 The Swamp {1888-1898} 21

 The Golden Era {1899-1913} 31

 A Fire Trap in the Heart of the City {1914-1939} 46

 A New Beginning {1940-1980} 55

Speaking Through Memory, by Patricia Owen

 Law 57

 Lee 75

 Quan 93

 Shiu III

Remembering Yi Fao 126

Bibliography I4I

❦ INTRODUCTION ❦

THE STORY OF NEW WESTMINSTER'S CHINESE-CANADIAN COMMUNITY, or Yi Fao, is fascinating and complex. No single chronicle of this community's 100-year history could ever capture its incredible range of individual experiences and stories.

A common belief is that the history of Chinese immigrants in the Royal City ended when Chinatown ceased to be part of the cityscape. However, the strength of New Westminster's Chinese community and its family ties is much more than just a collection of buildings. Yi Fao has evolved beyond the loss of New Westminster's old Chinatown and continues to be an important part of the city today.

Yi Fao: Speaking Through Memory explores the experiences of New Westminster's Chinese-Canadian community through its people's own stories and memories. The book title derives from the city's Chinese name, Yi Fao, or "second port," a reference to New Westminster's place as the second port of entry to British Columbia after Victoria. Over time, however, Yi Fao has come to mean the wider community of Chinese immigrants who made New Westminster their home.

This project seeks to honour New Westminster's Chinese community by preserving and celebrating the voices and personalities of these immigrants who made such an important contribution to the city's development. Descendants of New Westminster's Chinese settlers were sought out and interviewed, and four families became the focus for a museum exhibit and this book: the Law, Lee, Quan and Shiu families.

Within each family, children, siblings, grandchildren, grandparents and in-laws recount their memories of life in New Westminster. Their stories are grouped in the four main chapters of this book, accompanied by a historical narrative that helps to place their memories in a broader context.

Shared memories and family lore provide glimpses into history that are both compelling and poignant. The stories here reveal not just facts and dates, but also paint a picture of another era, colourfully revealed through the storytellers' personal experiences and emotions. Accounts from different generations of these four families provide us with a rare gift: an intimate insight into their own lives and a unique snapshot of the city's old Chinatown.

In order to provide a wider context for the family histories, this project also sought other voices from the past, as expressed in local newspapers, archival records and in the personal stories of other community members. However, this history endeavours to look beneath and beyond headlines and superficial facts, sensational though they may be, to focus on the authentic accounts that reveal the solid character and great strength that have been the pillars of New West's Chinese community from its beginning.

The story of Yi Fao is a history of struggle, adventure and achievement. Yi Fao has left New Westminster with a great legacy, as successive generations of Chinese-Canadians continue to enrich the culture of our city and nation.

A HISTORY OF Yi Fao

GOLD MOUNTAIN {1858–1880}

THE DISCOVERY OF GOLD ON THE FRASER RIVER IN 1858 BROUGHT the promise of wealth to immigrant Chinese labourers desperate to improve their lives in a rapidly changing world. News of the gold rush spread quickly through newspapers and journals, soon reaching California, the location of the 1849 gold rush and home to a large population of Chinese gold miners and merchants eager to pursue the next "Eldorado." Many of the Chinese in California were economic refugees who had fled rebellion, famine and unemployment in their homeland; overseas migration was an attractive prospect, especially for young men with few opportunities.

Through the tightly connected world of Asian-American shipping interests and Chinese merchants who acted as labour contractors, news of the latest gold strike spread back to China. British Columbia became known as Gim Shan, or "Gold Mountain." For many Chinese in dire need of work, it was a place that could change their lives and enhance the wealth and prestige of their family, or *jia*. But raising the funds for ship's passage was a challenge. Many young men obtained their fares through the "credit-ticket" system offered by wealthy merchant labour contractors in BC, whereby the contractor paid for an immigrant's travel expenses and recovered his investment through that person's labour in the goldfields. Many labourers struggled to repay this debt and, at the same time, send meagre payments home. However, even during the long years away from their families and homeland, the workers were sustained by the dream of one day returning home wealthy to marry and have children.

The initial wave of Chinese workers to BC came directly from California; as many as 2,000 men made the journey north in the first two years of the gold rush. The majority passed through the port city of Victoria before loading onto boats bound for the Fraser River and the interior goldfields. By 1863, 4,000 Chinese people were working on the mainland. New Westminster, which Queen Victoria had designated the capital city of the new Colony of British Columbia, became home to a growing population of pioneer Chinese immigrants.

New Westminster struggled to establish a port during its early years, but eventually it became the second port of entry to the province after Victoria and was known to Chinese immigrants as Yi Fao, or "second port." As early as 1860 it was reported in the city's local newspapers that a large number of Chinese people were camped on the public square known as Victoria Gardens. By 1861 the arrival of 52 Chinese immigrants directly from China was local news; speculation about another 200 arriving from San Francisco was seen as an indication of the colony's progress. Chinese businesses, including Hi Sing House, a laundry business opened in 1861, and the Colonial Bakery, operated by Ah Gee, were quick to seize on the business opportunities that presented themselves in the new capital city. The citizens of New Westminster welcomed and patronized these new services.

However, the presence of so many newcomers brought heightened tensions too. Racism pervaded newspaper reports of the day. One writer for the *New Westminster Times* dismissively commented that the fledgling Chinese community had little to offer the city but would " . . . no doubt add to the business of the place so far as the consumption of rice is concerned."[1]

By 1864 the gold rush had turned into a bust. With the exodus of miners, the entire economy of the region collapsed. New Westminster faced an economic crisis too, which ultimately led to the loss of its status as the capital in 1866, when Victoria was made the capital of the expanded Colony of British Columbia, which now included Vancouver Island. Most Chinese immigrants returned to China; it was estimated in 1866 that only 1,705 remained in the colony. A few remained at work in the goldfields, working at claims long abandoned by others and with incredible determination and perseverance,

1 *New Westminster Times*,
November 24, 1860.

14

finding gold and making a profit. Others followed their labour contractors to coastal cities to work in other industries.

The labour of these pioneers was invaluable to the economy and infrastructure of the young colony and pivotal to the growth of New Westminster. One example of their early achievements was the construction of the telegraph line between New Westminster and Quesnel. The Western Union Company employed over 500 Chinese workers to clear the line, erect thousands of poles and string telegraph wires between them.

A few Chinese immigrants were able to find work in New Westminster by working as servants for wealthy families in need of household assistance. The tradition of employing young female servants from the British Isles became nearly impossible to uphold, because as soon as young women arrived in the colony, they became the object of innumerable marriage proposals. Soon the Chinese houseboy was not merely a standard fixture in many homes, but an indispensable support for overworked housewives and a valued member of the family. These personal relationships were the foundation for strong and enduring ties between the local Caucasian and Chinese communities.

Other Chinese immigrants, ones who had freed themselves from their debt to labour contractors, established small businesses, doing laundry or cutting wood. These entrepreneurs were important to the city's economy and to the established families and businesses that relied on these services.

By 1867 the Chinese population of New Westminster—66 men and 37 women—was reported to be one-tenth of the city's total. But the actual number of residents was likely much higher, especially during winter, when Chinese workers flocked to coastal cities to escape the snow and cold temperatures of the Interior.

The presence of Chinese women in the colony was a strong sign that Chinese families were establishing their permanent homes in British Columbia. One of the colony's pioneer Chinese families was headed by Won Ling Sing, who had originally emigrated from China's Canton Province to San Francisco, where he entered into an arranged marriage with Wong Shee. The young couple came to BC in 1860, founding a business at Port Douglas and moving it to New Westminster's Chinatown in the early 1870s. This

family would make its mark on the city and the country. Their first-born, a son, was Won Alexander Cumyow, who was born in 1861 in Port Douglas and later claimed to be the first Chinese-Canadian born in BC. Their daughter, Won Elizabeth Cumyow, born in New Westminster in 1871, was the first Chinese-Canadian female born in BC. Another son, Won Joe Quoy, lived his entire life in the Royal City and became a noted sportsman. A successful jockey, he was the first Chinese-Canadian to break race barriers in the sport of horse racing.

The Won family was just one of many prosperous Chinese merchant families to recognize the growing need for stores, housing and businesses, not just for their own compatriots, but also for the general population. These stores and businesses formed New Westminster's first Chinatown, which took shape on land that was primarily leased from Caucasian landowners, including the estate of former governor Sir James Douglas, on the eastern end of Front Street. This section of the city, bounded by the rocky, undeveloped riverbank of the Fraser and an escarpment separating it from the residential district above, was isolated from the downtown commercial area.

New Westminster's Chinatown also served as a winter resort for contract workers from the Interior, who came to indulge in the comforts of being part of a shared community. For many of the young labourers the pleasures of gambling, smoking opium and visiting houses of prostitution served as a diversion from the drudgery of their daily life of hard work.

New Westminster and its surrounding district slowly began to recover after the end of the gold rush. Its new economy was based on the establishment of the lumber, fishing and agricultural industries of the Fraser Valley. Many of these businesses relied on cheap labour supplied in quantity by Chinese contractors. The salmon canneries on the New Westminster waterfront along the Fraser River were among the largest employers. By 1879 the population of the city's Chinatown was estimated in an official census to be 300, including cooks and servants, labourers, vegetable gardeners, woodcutters and laundry workers. But, like all other Chinatowns, it was still a largely a bachelor society, with only 10 Chinese women in the community, a decline from the 37 enumerated in 1867.

New Westminster's Chinese people actively celebrated their community

and took pride in their culture. In 1872 the *Mainland Guardian* noted that they were celebrating their New Year with a "large expenditure of fire crackers."

Chinese citizens also participated in civic events. During a visit by Canada's Governor General Lord Dufferin in 1876, local Chinese merchants built an arch on Front Street displaying the mottoes "God Save the Queen" and "The Dominion Forever"; the arch was beautifully lit with Chinese lanterns at night.

A LITTLE BIT OF OLD CHINA {1881-1887}

In the 1880s the entire economy of BC—including New Westminster's—was buoyed by the announcement that the province would finally be connected to the rest of Canada by the Canadian Pacific Railway (CPR). Andrew Onderdonk, the contractor for the Pacific section of the railway, needed Chinese labourers to complete this incredible feat of engineering and brute strength. Suddenly thousands of Chinese workers were arriving in the province, passing through New Westminster on their way to the work camps up the Fraser River. In 1881 a total of 2,939 arrived; in 1882 a staggering 8,083 workers entered the country. Of the 3,223 who immigrated in 1883, 793 came from Puget Sound; 1,874 from California; and 556 from China.

The impact on the city was profound and immediate. New Westminster's waterfront and port became a transfer station for goods and men, and quickly transformed into a hub of activity. On Chinatown's Front Street, new buildings sprung up, lining the waterfront between Lytton Square and the woollen mills to the east. Narrow two-storey wooden tenement blocks were built on every available piece of land to house Chinese workers, stores, restaurants, gambling dens and joss houses, creating a little bit of old China on the Fraser River.

Conditions for these latest immigrants were deplorable. In 1882 a near riot occurred between two distinct factions of Chinese newcomers when a group of 900 was loaded off a vessel and kept on the dock penned up "like cattle" overnight before being transferred to another boat to take them to work camps. City officials had refused to permit the labour contractors to allow the Chinese workers access to the city, fearing the spread of any disease they might have been carrying.

Racism and fear of crime were on the rise throughout New Westminster, much of it centred on the growing Chinatown, as reflected in this newspaper's report:

> The smell of roast cabbage, cats and sin pollutes the air in that part of Front Street north of Melody's Saloon. Surely it is time for City Fathers to think of removing the Celestial iniquities to a place somewhere outside the city limits. If they will not or cannot do so, let them insist on having the laws of decency observed and compel the Celestial population to shut up the traps into which young men are enticed by Indian women and opium. The private history of the north end of Front Street is fit for publication in the lower regions, but no other place.[2]

2 *Mainland Guardian*, "Briefs," January 27, 1886, p. 3.

On the other hand, many residents saw the expanded Chinatown as a curious and exotic addition to the city, especially during the increasingly elaborate Chinese New Year's festivities. In 1886 hundreds of citizens witnessed a grand display of fireworks put on by the local Chinese community and happily participated in their New Year celebration. It was reported:

> Our moon-eyed brethren treated us to a grand display of fireworks Thursday evening and hundreds of spectators thronged Front Street to witness the illuminations, Fire-crackers, rockets, bombs, and other explosive materials were set off in abundance, the object of which seems to be—the frightening of the devil from our midst for the balance of the year. The Chinese band added "sweet discourse" to the proceedings, and their musical propensities were somewhat heightened by the beaming countenance of a roast hog . . . Without pork the Chinaman cannot celebrate, and at the close of the performance several fat jolly looking self-made celestials discovered that the roast hog would be a good thing to have a picnic on, and they wound up the entertainment with a grand feast.[3]

3 *Mainland Guardian*, "Chinese Jubilee," February 20, 1886, p. 3.

As the Canadian Pacific Railway neared completion in 1885 after four and a half years of construction, gangs of Chinese labourers found their way back to New Westminster, Nanaimo and Victoria looking for work. Many workers faced extreme poverty, having no funds to return to China and no other prospect for making a living. Labour contractors, so eager before to bring out new workers, abandoned many Chinese workers once their commissions

were paid. This situation led to deplorable conditions in New Westminster's Chinatown. The community and city council were so concerned that a committee was formed to collect funds for a soup kitchen to be set up in the old jail "to give some assistance to the unfortunate wretches left here by syndicates to starve."[4]

4 *Mainland Guardian*, January 27, 1886, p. 3.

During this period, some of these destitute immigrants were assisted by New Westminster's benevolent associations. The Chinese Freemasons, first established in Barkerville in 1862, was one of the earliest groups in the city, and many prominent merchants in New Westminster were members. Although it is not known when the city's Freemasons branch was officially established, as early as 1882 delegates from New Westminster attended the opening of a "Freemasons temple" in Yale.

New Westminster was also home to one of the oldest Chinese Benevolent Associations (CBAs) in Canada. When Victoria's Chinese community established its CBA as a Canada-wide association in 1884, New Westminster's Won Alexander Cumyow was its English-language secretary. Sometime after that date New Westminster's local CBA was established, and by 1896 its members signed an important petition along with the CBAs of Vancouver and Victoria. The Chinese Freemasons, the CBAs and family clan associations were extremely important parts of the social, financial and political support structure of the Chinese community.

Despite the dire economic conditions faced by some former railway workers, the Chinese population of New Westminster continued to play an instrumental role in the city's economic advancement. The construction of a CPR spur line connecting New Westminster to the main line was accomplished by Chinese workers, who did the clearing and grading. Chinese labourers also found work building the new terminus at Vancouver, which would quickly replace New Westminster as the premier city of mainland British Columbia.

The growing presence of Chinese people in the province was being met with increasing hostility from local working-class Caucasian workers. The Dominion government had earlier responded to British Columbia's racist fears and demands for the exclusion of Chinese from the province by imposing the Chinese Head Tax as part of the Chinese Immigration Act of 1885. Intended

This lithograph of the Kwong On Wo & Co. store on Front Street was featured in the 1890 "Birds-Eye-View" of the city produced by the *Vancouver World* newspaper, an indication of Kwong On Wo's prominence in the local business community.

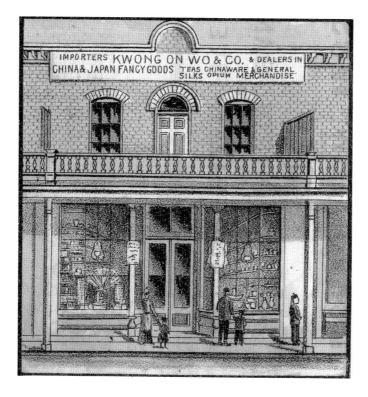

In this 1889 view of the city, the Chinese boatman seems posed to showcase the booming Front Street Chinatown so clearly visible along the waterfront between Lytton Square and the woollen mills.

IHP 311

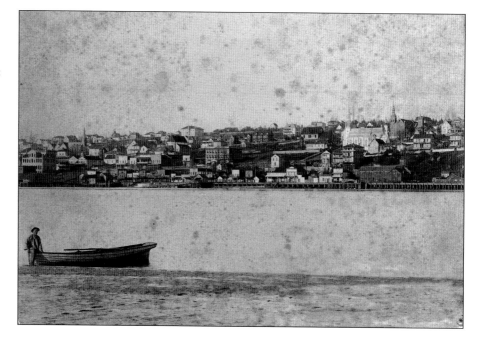

to discourage immigration, the head tax instead just added another unfair financial burden onto the Chinese labour migrants.

In Vancouver, the hostility toward Chinese labourers boiled over in 1887, when on several occasions mob violence by Caucasian labourers forced Chinese workers to leave Vancouver for the safety of New Westminster's established Chinatown. Soon, however, Vancouver's Chinese community would become firmly established, eventually becoming the largest Chinatown in Canada.

THE SWAMP {1888–1898}

New Westminster was now in the midst of a tremendous economic boom as a result of its connection to the Canadian Pacific Railway and the construction of the Vancouver terminus. Its own Chinatown had also contributed to and benefited from the economic growth and success of the Royal City. One of the businesses that would grow to become the city's largest was Kwong On Wo store, founded in 1887 with a substantial capital input from Chinese investors. Unlike other Chinese stores, which were crowded into the ghetto on the eastern edge of Front Street, Kwong On Wo had the capital to purchase a portion of the handsome brick-built Armstrong Block, located west of Lytton Square on Columbia Street. Kwong On Wo was said to have been the largest Chinese labour contractor in BC and controlled 75 percent of all the Chinese workers on the CPR line through its prominent labour contracting agent, Yip Sang. Later Kwong On Wo opened a fish and fruit cannery in Queensborough called the Westminster Cannery. The prominence of Kwong On Wo and its important contribution to the economy of the city was recognized through flattering local newspaper reports and its inclusion on published lists of the city's industrial concerns. As one newspaper reporter commented:

> In addition to keeping on hand a large and well assorted stock of Chinese and Japanese ware, including tea, silk, china and fancy goods, Kwong On Wo & Co. import large quantities of rice in sacks, scores of which are piled ceiling high in the firm's warehouse on Front Street. The cereal is imported in a semi-finished state, and a feature in connection with the business which is well worth seeing is the process employed by the company of cleaning the

rice and preparing it for the British Columbia market . . . The machines—there are 12 of them—are operated by foot. They resemble more than anything the contrivances pictured in early prints of medieval grain cleaning, or crushing.[5]

5 *Sun*, "Cleaning Rice," April 9, 1898, p. 4.

Kwong On Wo also thrived on the manufacture and distribution of opium, which was sold through its New Westminster store and supplied in quantity to the workers it employed as a major labour contractor. The company's opium factory was an important part of its financial success, and it operated in the heart of the City's downtown. "Here the opium is received in its rough state (valued at $15 a pound) and put through the different processes of roasting . . . until it is turned out ready for the pipe . . . work in these mills and factories gives employment to a large number of men."[6]

6 *New Westminster Columbian* supplement, "The Colony of Chinese," December, 1903, p. 66.

However, the opium manufacturing process caused an overpowering smell of fumes that hovered low in the air along Front Street and elicited many complaints. The company tried— without success—to solve the problem by erecting a tall smokestack to carry away the fumes. The *British Columbian* complained that "the lofty carry-off chimney to do away with the sickening fumes was tried today for the first time and the trial show[s] that it is by no means a success. If anything the stench was worse than before and pedestrians passing along Columbia Street remarked it all day long . . . the public must not be choked . . . The Chief of Police is going to further investigate . . ."[7]

7 *Daily Columbian*. Local and Provincial, August 21, 1890, p. 4

Despite the establishment of the new Chinatown in Vancouver, Yi Fao continued to grow at an accelerated pace. City council was struggling to improve the urban conditions of the young city, and they viewed the Chinese quarter as a serious health and crime risk. The chief of police was sent on an annual tour of inspection of Chinatown to order health violators to clean up. On one tour the chief took along a local reporter, who wrote:

> A number of houses were visited . . . then came a rookery. Proceeding along a narrow passage between two houses and up a flight of narrow stairs the Chief led the way through tortuous passages lined on either side by series of little dens in which cooking, smoking and laundry were being carried on . . . In each of the little rooms or rather closets, into which the house was divided, being hardly enough to turn around in, were men lying on their

backs placidly puffing away at the opium pipes. The rooms themselves were dimly lighted by the little lamps used by the smokers to light the beads of opium placed in the bowls of their pipes.[8]

8 *Daily Columbian*, "Celestial Homes," April 29, 1891, p. 4.

With no room left for Chinatown to expand on the 10 leased lots on Front Street, Chinese merchants purchased land in the western part of downtown—an area bounded by Columbia, Tenth, Blackie and Carnarvon streets that was popularly known as "the swamp." This area had a wholly unsavoury atmosphere and was home to several rough bars and hotels such as the Cleveland, which catered to working-class Caucasian immigrants. Here housing, stores and even sidewalks had to be built high on piles to keep out the muck and flood tides of the Fraser River.

The more prominent of the first Chinese businesses established here were Ying, Tai & Company, a firm of labour contractors that opened in about 1889 at Tenth and Carnarvon streets, and Sing Kee, a general merchandise store that opened around 1890 at Columbia and McInnes streets. Packed in around these businesses were livery stables, Chinese laundries and tenements. The area was far from ideal, but by 1892 the majority of the land in it was owned by wealthy Chinese, giving the community a sense of stability and permanence.

The swamp was also the chosen location for the Chinese Methodist Mission Church. Under the leadership of Reverend J.C. White, the Methodists were prominent missionaries working in the city as early as 1859. In 1883, Reverend Ebenezer Robson, along with his wife and daughter, started a separate Chinese mission. Mrs. James Cunningham operated a night school to teach English, and Robson noted in his diary that the nine students who arrived on the first evening were "apt scholars."

The Chinese Methodist Mission Church opened in 1892 at McInnes and Holbrook streets under Reverend Chan Sing Kai. Later, Reverend Tom Chu Thom led the church from 1897 to 1906; Thom had come to BC in 1883 to work on the CPR and had later worked as a houseboy for the Cunninghams.

Although sympathy for Chinese immigrants was common among the city's church-minded citizens, Chinatown was often the scene of random acts of racism that threatened the lives and livelihoods of the residents. Evidently, Chinese citizens organized to protect one another from violence and injustice.

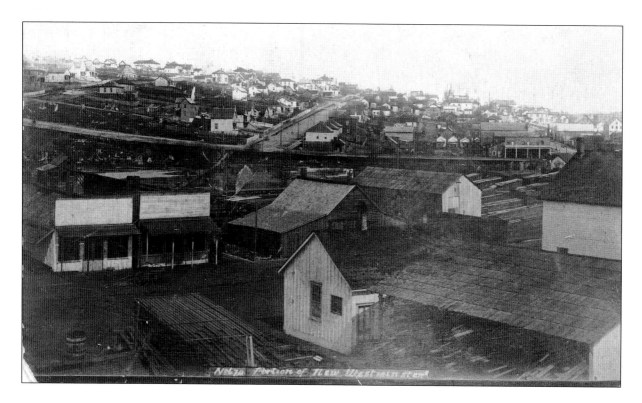

This view of the city, looking east from the Royal City Mills property c. 1889, shows the swamplands reclaimed by Chinatown in the 1890s. The Ying, Tai & Company store, at the right of the photo, was at the corner of Tenth and Carnarvon streets.
IHP 3085

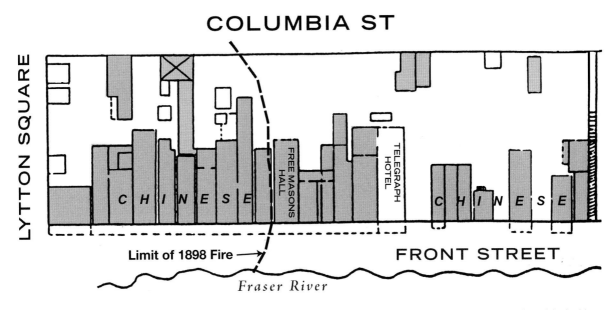

COLUMBIA ST

LYTTON SQUARE

FREE MASONS HALL

TELEGRAPH HOTEL

CHINESE

CHINESE

Limit of 1898 Fire →

FRONT STREET

Fraser River

This 1885 plan of the buildings of the old Front Street Chinatown shows the extent of destruction caused by the Great Fire of 1898.

Courtesy of Jim Wolf

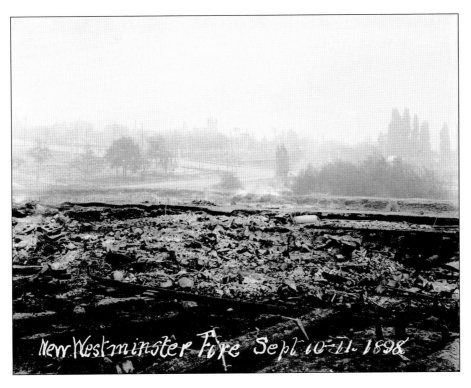

This September 11, 1898, view of the swamp from Columbia and McInnes streets after the Great Fire shows still-smouldering debris and the complete devastation of the city's Chinatown.

Frederick Chapman photograph, IHP 3088

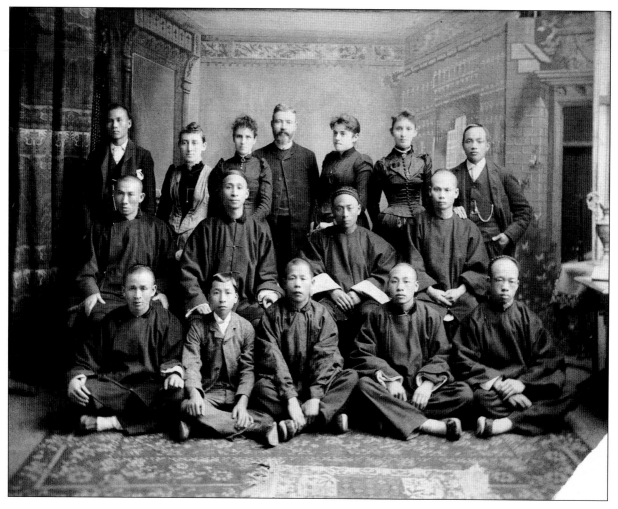

This rare studio portrait, c. 1890, is of the staff and students of the Chinese Methodist Mission, which was headed by Reverend Robson. Reverend Robson and a group of female teachers can be seen in the back row, surrounded by students in both traditional and western clothes.

S.J. Thompson photograph, IHP 2729

On one occasion, an intoxicated man wandered into Chinatown and violently grabbed a Chinese resident by the throat, pushing him through a plate-glass window. It was reported that "as soon as the frightened Chinaman could free himself, he blew a whistle and in an instant about forty pigtails were in pursuit of the assailant."[9] When New Westminster police marched into Chinatown to arrest a Chinese woman accused of a theft in Vancouver, the "denizens of the Chinese quarter ... swarmed around the officers like bees, and for a short time it looked as though they would make an attempt at a rescue."[10] In both incidents, however, the Chinese people involved were later diligent in their cooperation with local police, despite ever-present language barriers.

9 *Daily Columbian*, "Rather Too Jolly," June 1, 1891, p. 4.

10 *Daily Columbian*, "Chinese Woman Arrested," November 25, 1891, p. 1.

Often local Chinese merchants and associations received help communicating in English from the British Columbian-born bilingual brothers Won Alexander Cumyow and Won Joe Quoy. Not only could they both speak English, but they were also fluent in two Chinese dialects, Cantonese and Hakka, in addition to Chinook, the trade language of the west coast. Cumyow, acting on behalf of the local Chinese Benevolent Association, often communicated with city council regarding the Chinese cemetery.

In 1892 the Chinese community was intent on establishing its own cemetery to accommodate its culturally important rituals; the location of choice was the city-operated potter's field known as the Douglas Road Cemetery. Although the Chinese had been burying their dead here for years, the growing population (and the proportionally growing number of deaths) created a need to expand and control their own section of the cemetery. The Chinese cultural practice of shallow burials and disinterment of bones for shipment back to China was often the cause of disagreements between community members and the sanitary inspector, Sidney Pearce, and city council.

The Chinese community responded by having the fluent and educated Won Alexander Cumyow act on their behalf in 1892 to secure the required land and obtain city council's permission to build a brick altar and furnace for their burial rites. In return for permission to create their own cemetery, the Chinese merchants organized work parties to clear broom and brush from the cemetery, which was described as "wonderfully improved" by the local press.

Chinese funerals for prominent and wealthy merchants were events that

captured the attention of the city and were reported in detail in the local newspapers. In 1891, the *British Columbian* reported:

> The celestial quarter on Front Street was in a state of great excitement today, preparing for the Funeral of the late Ding Ah Wong, the head of the Chinese Masonic Order in this city. The dead tyhee has been lying in state in a little house on Front Street for the last five days. Last evening, about 6 o'clock, the rattle of firecrackers was the first information to outsiders that anything unusual was going on, and all night arrangements were being made for the funeral. This morning the Joss House was decorated with flags and streamers, and under an awning on Front Street tables were laid out with roast chicken, pig and other Chinese delicacies. The gongs of the Joss House were beaten every few minutes, and a musician posted on the verandah played doleful Chinese music on a pipe that sounded something like the bagpipes. The dead man was dressed in blue, with a red cloth spread over his breast, and his meerschaum pipe, tobacco and opium were placed in the coffin with him. At 1 o'clock a large number of Chinese dressed in various uniforms, many of them in flowing robes of white with their heads bound with red and white cloth, formed in two lines on the street. A mat was placed at one end of the tables and the widow dressed in white was led from the house. The coffin was next borne to the trestles facing her, while incense was burned to Joss, and the gongs and horns kept up a continuous din. The funeral started shortly after 2 o'clock and the procession made a gorgeous appearance. The funeral . . . is said to have cost the relatives of the deceased fully $1,000.[11]

11 *Daily Columbian*, "Chinese Funeral," June 11, 1891, p. 4.

In Chinese tradition, ancestors, once buried, must never be forgotten. This cultural practice was explained by one reporter who wrote:

> There was an unusual stir in the Chinese quarter on Sunday. The Chinese burying ground early in the day was made a place of rendezvous by some dozens of Chinamen in cabs, express wagons, etc. A Chinaman said in his characteristic accent "This is a Chinese picnic for the dead. We have three each year, one in the China March, another in July and a third in September." The grave of nearly every departed Chinaman was bedaubed with a collection of candles and square-cut paper which was perforated to make it difficult for the approach of evil spirits as it would be necessary for

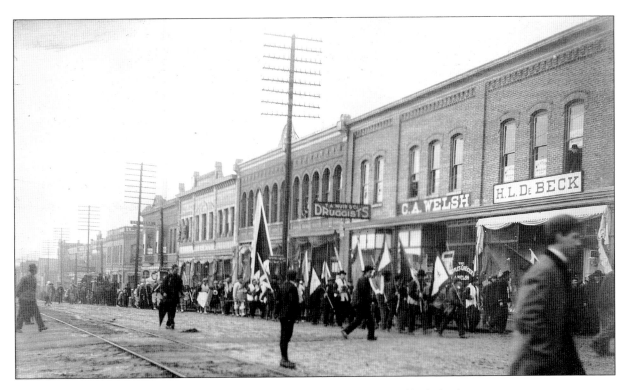

The highly ceremonial funeral parade in honour of Chinese merchant Tai Kee was conducted by the local Chinese Freemasons, who marched in traditional funeral costumes and carried flags representing their order. In this photo taken March 7, 1902, the parade is seen approaching the corner of Columbia and Sixth streets as it proceeds east en route to the Chinese section of the Douglas Road Cemetery at Eighth Street and Tenth Avenue.

IHP 0616

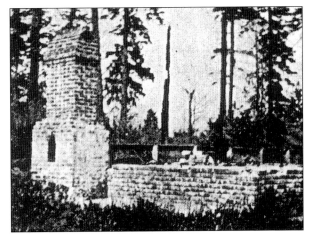

This brick furnace in the Chinese section of the Douglas Road Cemetery (now the site of the New Westminster Secondary School) was built in 1892 by the Chinese Benevolent Association for use in its many cultural rituals associated with burying and honouring the dead.

Photo, c. 1910, courtesy of Jim Wolf

12 *Evening Sun*, "Dead Man's Picnic," April 9, 1898, p. 4.

them to pass through the tiny holes. There were liberal portion[s] of tea, Chinese pastry, cooked chickens, with boiled pig, and after dinner cigarettes distributed among the graves.[12]

Another important cultural aspect to the burial custom of these early immigrants was the need to ensure that the bones of the dead were later exhumed and returned for final burial in China. In the early years this work was contracted to local merchants such as Kwong Man Yuen, who in 1890 disinterred over 80 bodies for shipment. However, the work was later left to the local Chinese Benevolent Society, which coordinated this important task with the Victoria CBA.

The general economic depression following 1892 put a significant damper on further economic growth in New Westminster and Chinatown, but it was the Great Fire of 1898 that would profoundly change the character of the city. The fire began on a hot summer's night on September 10, 1898, in a pile of hay beside the city market in Lytton Square.

The fire had spread in less than no time eastward to the city wharf and Market building. This was but a mouthful for the hungry fire devil and in an instant the Chinatown of the east end, which is on Front Street east of Lytton Square, was blazing from one end to the other. Out on the street the scene passes adequate description. Frenzied Chinamen rushed up and down in agonies of despair. They shrieked and prayed to all the gods and devils in the Chinese mythology, but never for a moment did they cease in their struggle to save what stuff they could from their hovels and shops now rapidly being consumed. Acting Chief Watson, who in the absence of Chief Ackerman, had control of the brigade, recognized the utter futility of trying to save any of the wharves or property in that immediate vicinity. The terrible rapidity with which the conflagration spread, paralyzed the brigade which was handicapped by the miserable water supply, while private citizens could do no more than look on . . . The Chinese store of Kwong Wing Lung Co, kept [back] the oncoming flames but a few seconds, and here the most tragic moment of the fire occurred. Mun Lee, the head of the firm, one of the wealthiest Chinese merchants in the Royal City, rushed into his store in some wild attempt to save his money. He reached his cash box but just as he grasped it he fell back dead. His corpse was carried to

a place of safety and a medical man saw immediately that heart disease had been the cause of death.[13]

13 *Province*, "Gone up in a Hell of Flames," September 12, 1898, p. 1.

The firestorm spread down the docks lining Front Street and quickly jumped to the buildings along Columbia Street, destroying all the brick blocks, including the Kwong On Wo store and a staggering $20,000 worth of opium held there. To the west, the fire quickly consumed the swamp and the wooden buildings of Chinatown. The fire was so hot that little in its path was left standing, but by some strange miracle a few wooden buildings somehow escaped the intense heat, including three Chinese stores and tenements owned by Sing Kee at the corner of Columbia Street and McInnes streets. The fire finally burned itself out at Tenth Street and Royal Avenue, leaving a scene of devastation in its wake. It was an appalling chapter for the city's history.

THE GOLDEN ERA {1899-1913}

In the aftermath of the fire there was little left for the Chinese community to salvage. On the furthest eastern extreme of Front Street, only a few Chinese merchants and their stores and tenements were left standing. The Chinese Benevolent Association in Victoria immediately sent $500 to help; the next day it sent another $1,000 to assist Chinese people who were left homeless. A significant shift in Chinatown was underway as Chinese merchants decided to invest in construction on Chinese-owned lands in the swamp rather than on Caucasian-owned lots on Front Street. City officials, now paranoid about the threat of urban fires, insisted that what was left of the old Chinatown on the waterfront be demolished immediately. Fire Chief Watson recalled:

> I condemned all the buildings and with the backing of the council gave owners 14 days notice to tear them down. The owners included Ben Douglas and Henry Elliot, and a lot of other well-known old timers. They made no move. We gave them one day's grace. Still no move. So I took a gang of men, the steam roller and 200 feet of cable. The first house we came to was empty. We went in the front door with the cable, and out the back door, hitched it up and gave the roller engineer the signal. He started up and the building came down like a house of cards. As soon as she started to crack, the Chinamen began to swarm out of the other houses. By the time we

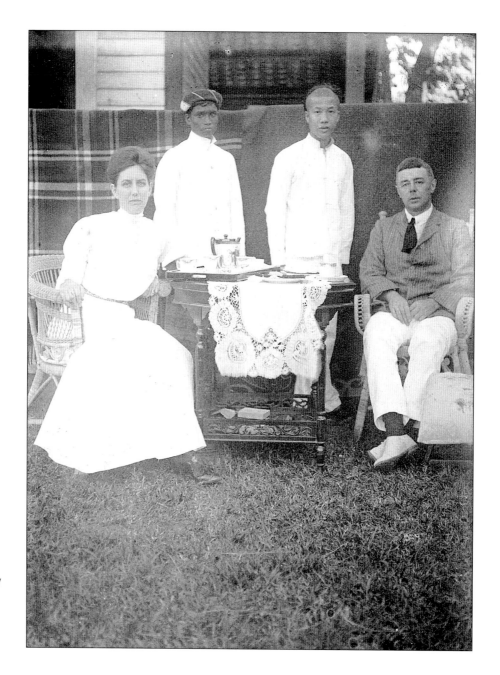

Maude and Frank Green enjoy
tea served by their houseboys
on the lawn of their Royal
Avenue home, c. 1905.
IHP 2644-100

got to the next house it was empty and the door step was piled high with Chinese dunnage. In one day we tore down every building in Chinatown. Then we set fire to the debris and cleaned it up.[14]

14 *British Columbian*, "Old Building is a Menace," August 27, 1921, p. 1.

The new Chinatown in the swamp was built at an impressive pace following the fire, demonstrating the economic strength of the community and its merchants. Even though the remnants of the old Front Street Chinatown had been demolished, Kwong On Wo lost no time in re-establishing its lucrative opium business, erecting a one-storey brick block at its old Front Street site at a cost of $4,000. It was the first brick building constructed by any of the city's merchants after the fire.

Kwong On Wo also purchased a prominent Columbia Street lot near McInnes Street, adjacent to the surviving Sing Kee establishment at the edge of the swamp, and commissioned architect T.E. Julian (who served as a volunteer with the local Chinese Methodist Mission) to design an impressive $11,000 brick block that required piledriving and filling of the swampy site. The building was an exotic addition to Columbia Street's business blocks, incorporating odd parapets and decorative elements likely intended to evoke the architect's misconceptions of Chinese architecture. The company's manager, Lee Ching, also ensured that the new structure incorporated a traditional walled compound at the rear of the store for his family. Behind the safety and privacy of tall brick walls, this wealthy family would dine in their private garden, enjoying meals prepared in the outdoor kitchen.

Chinatown's other new buildings, constructed by gangs of Chinese workers, were primarily two- and three-storey wooden structures that served as combined apartment-and-store blocks. The city—now paranoid about urban fires—allowed the construction of these wooden structures only because they were outside the core of the downtown business district to the east, which was governed by new fire regulations.

Chinatown's new buildings featured many traditions of Chinese architecture such as recessed second-floor balconies. The new Chinatown also incorporated several narrow pedestrian alleyways behind the buildings, and public toilets or "comfort stations," both of which were new features—the latter doubtless much appreciated by all the district's visitors.

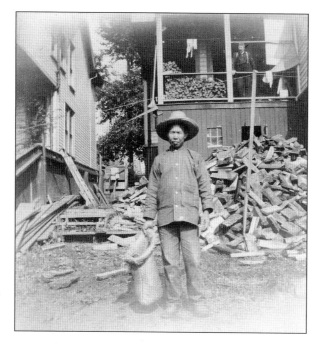

A Chinese woodcutter poses beside his freshly cut stack of cordwood at the Green family house on Royal Avenue, c. 1908.
IHP 2644-017

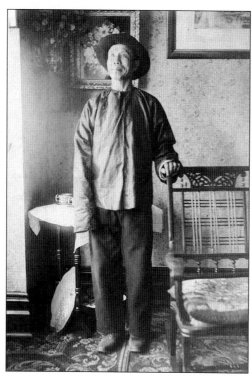

This Chinese house servant must have enjoyed a respected postion in New Westminster's Dingle family in order to have merited such a flattering personal portrait, taken c. 1905.
IHP 3631

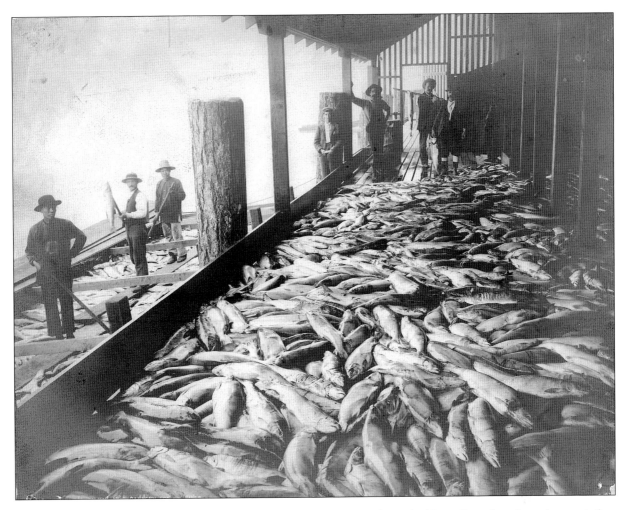

Chinese workers unload Fraser River salmon from a barge onto the dock of the Butterfield and Mackie Cannery at 537 Front Street, on the city's waterfront, c. 1905.

S.J. Thompson photograph, IHP 0361

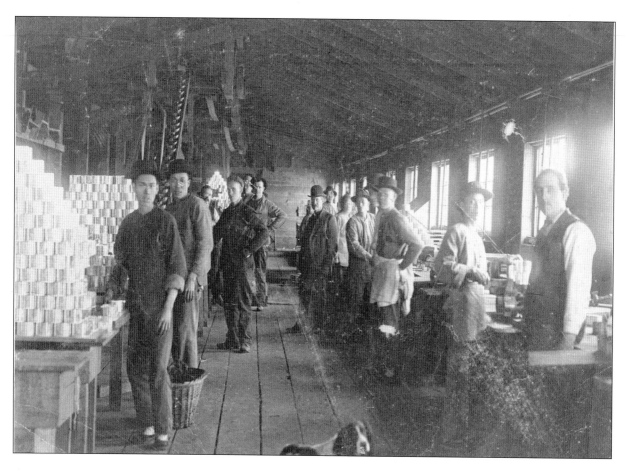

Chinese metalworkers in the production line at the Cleeve Canning
Company on Front Street pause to pose for this photograph, c. 1902.
NWPL 790

The main shopping district, with over 20 storefronts, was centred on McInnes Street between Columbia and Carnarvon. After the fire, construction of wooden frame buildings, at a total cost of over $25,000, was carried out by Chinatown merchants and landowners. Tai Loy & Co. built a "two-storey frame block"; Kwong Man Tai built a "store and dwelling"; Wing Sang built "8 stores"; and Ying, Tai & Company built a "two-storey frame block." Soon after, Lam Tung and Lee Soon built "two large three storey tenements with stores below," and Chen Nye and Ah Sam built "two large stores and dwellings."[15] Chinatown now had a compact and impressive group of business blocks, and was essentially a self-contained village bounded by McNeely, Columbia, Tenth and Carnarvon streets.

15 *The Columbian, Souvenir Edition Supplement*, "Burned and Rebuilt," October 4, 1899, p. 3

The Chinese Methodist Mission was also rebuilt, and opened to worship in 1900. By 1902 the church had 16 Chinese families as active members, including two merchants. The night school provided lessons in English to 40–50 students, and 15 boys attended public day school. (In 1903 the total population of the city's Chinese community was estimated at 900; however, the district population of the Fraser Valley served by New Westminster's Chinatown exceeded 2,600.)

This new Chinatown became the new primary site for the annual Chinese New Year's festival. The celebration, which lasted for a week, was exciting and elaborate and often described in detail by the *British Columbian*:

> If the average white person should happen to take a walk along the streets in Chinatown about this time he would probably conclude that the celebrations consists [sic] in discharging fire crackers and making as much noise as possible. All windows are barred and all blinds are down so that it is impossible to see what is going on inside. If he enters he will see . . . tables filled with roasted chicken, sweet meats, nuts, preserved ginger, oranges and all sorts of confections. The floors are covered with a thick coating of sawdust which serves to protect them from the staining effects of fruit and refuse. The first day of the festivities is devoted principally to visiting. An entire household starts out and calls at all the houses of their friends, where they are served first with . . . tea, then "sam suey" and finally cigars. The Chinaman's greeting to his visitor is "Kung E fa choy" (Happy New Year),

and as he says the words he advances smiling towards his friend, with hands clasped as though shaking hands with himself . . . The white visitors are treated with utmost courtesy by the Chinamen. This morning a crowd of boys invaded Chinatown and went from one house to another and were provided with sweetmeats of all kinds at each place. Grown-ups are generally offered cigars, "sam suey" or even champagne.[16]

16 *British Columbian Weekly*, "John Forgets His Troubles," February 19, 1907, p. 17.

In 1903 Chinatown was described in a special *British Columbian* supplement that featured the city's Chinese community in a flattering article titled "The Colony of Chinese: Citizens of New Westminster":

Situated in the southern part of the city, it is the typical abode in design and layout of the Oriental. [With] row after row of houses with their many dark entrances, one wonders how a man finds his own lodging house on the dimly lighted street. One thing noticeable about the residents in Chinatown is their cleanliness, and their willingness to adapt to the rules and regulations of the sanitary inspector . . . Particularly noticeable in the Chinese section here are the stores owned and controlled by the wealthy class. While naturally doing a large trade with their own people they also have the patronage of a large number of white residents.[17]

17 *New Westminster Columbian* supplement, "The Colony of Chinese," December, 1903, p. 66.

During this time around the turn of the last century, Yi Fao was growing and becoming more complex as various organizations and associations emerged to serve the needs of residents. In 1904 the Chinese Benevolent Association raised funds to construct an "Old Men's Home" on Holbrook (now Victoria) Street. This building would also become the CBA's headquarters, serving as a place for public meetings and gatherings. The Chinese Reform Association was a new organization, sparked into being after China's defeat in the Sino–Japanese War. One of China's leading politicians and advocates of constitutional reform, Kang Youwei, came to British Columbia to encourage reform among BC's Chinese population. On his arrival in 1899 Kang Youwei spoke to the Chinese community at a large rally held in New Westminster's Opera House, drawing hundreds of converts to the goal of establishing a constitutional monarchy in China. The New Westminster branch of the Chinese Reform Association was formed as a direct result of this visit.

The association soon grew to over 900 members, many of them

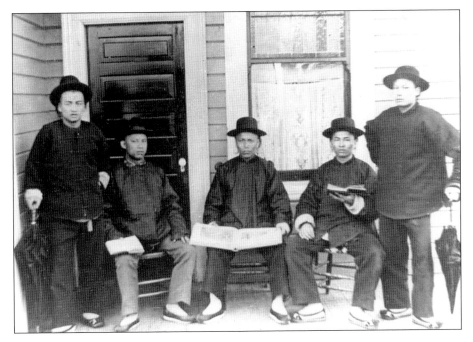

These young Chinese men at the William Johnston House take time to have their photograph taken, c. 1905. Perhaps the books seen in the photo were a way to indicate to family in China that they were learning to read and speak English.
NWPL 1865

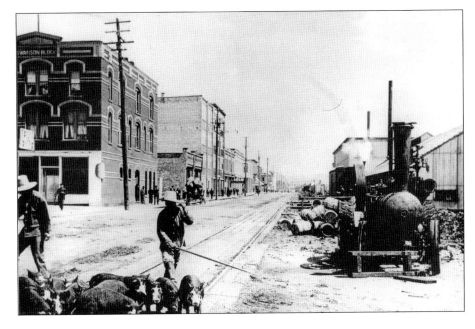

Chinese men, likely headed from the city market to Chinatown, herd pigs on Front Street, c. 1904.
Philip Timms photograph, NWPL 5

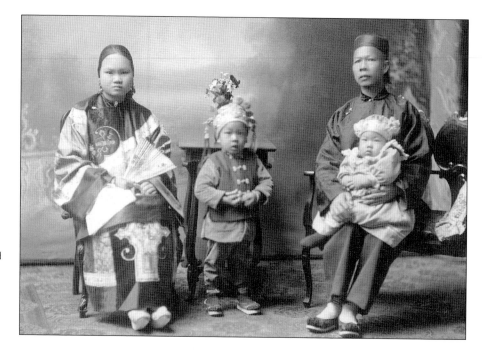

This charming studio portrait of Wo Ham and his family was taken in 1904 in New Westminster by studio photographer Frederick Easthope. Wo Ham was the cook on the "snag boat" named the *Samson*, which the federal department of public works operated on the Fraser River.
IHP 1042

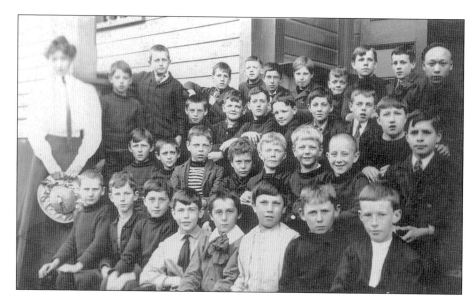

This c. 1908 portrait of a class composed mostly of Caucasian boys at New Westminster's Central School includes the singular image of a lone, older Chinese boy at top right. In 1911 the New Westminster school board banned all integrated classes, moving all Asian students into a tent-school in Tipperary Park and later into the old Westend School.
IHP 0890

working-class labourers who lived in communities on the Fraser River from Ladner to Chilliwack. Leaders were drawn from the wealthy and educated merchants of New Westminster's Chinatown. Law A. Yam, the manager of the local firm of Ying, Tai & Company was elected the "Grand Vice-President" of Canada, and Chon Lan (another Yi Fao resident) served as foreign secretary to the national organization. The Chinese Reform Association also led to the first documented Chinese women's organization in the city, the Chinese Empire Ladies Reform Association, composed of women from New Westminster and Vancouver.

Constitutional reform in China was only one focus of the Chinese Reform Association. Other goals were "to open up the ports of all countries so that Chinese citizens may have an equal footing with the residents of such countries, and enjoy the same privileges; also become citizens of each country and enjoy all of the same freedoms and have the rights of sufferage [sic]."[18] Another aim was to work towards the "suppression of all vices" within the community, including opium and gambling. The group's success in fighting gambling was limited; New Westminster's Chinatown was rife with gambling of all kinds. Sometimes the gambling caused major strife between Chinese players and the city police, as was reported in 1905:

18 *New Westminster Columbian* supplement, "The Colony of Chinese," December, 1903, p. 66.

> There were strenuous times in the Royal City Chinatown on Saturday evening, when the Chief of Police McIntosh and his merry men made another raid on one of the gaming-houses of the quarter . . . It was shortly after 9 o'clock that the police marched swiftly down McInnes Street and broke into the gaming house . . . where several fan tan tables were running full blast. The room was crowded with gamblers but only ten of the celestials were captured, for the owner of the house . . . had a large section of the back wall removed. Into this had been inserted a pair of doors so cunningly contrived that from the outside it was impossible to distinguish them. The police had no knowledge of any exit . . . No sooner had they entered the room than the side of the house swung open and scores of celestials poured into the open . . . The prisoners were shackled together and then the fun began. The news of the raid had circulated throughout the quarter and outside a turbulent mob of celestials waited for the police. No sooner did

they appear with their prisoners than they were greeted with yells of rage, and bottles, stones, sticks and any other kind of missile that the Chinamen could lay their hands on filled the air. The Chief ordered the officers to form round their prisoners, and using their batons with good effect, they fought their way out of the crowd.[19]

The popularity and success of the city's gambling houses were signs of the economic prosperity of the Chinese community. This extraordinary period of growth for Yi Fao, which mirrored the growth of British Columbia and New Westminster prior to the First World War, could be viewed as its "golden era." It represented the height of New Westminster's Chinese community's expansion and population growth. Chinatown benefited substantially from the expansion and commercialization of the fishing, timber and agricultural industries. Merchants who worked as labour contractors earned huge profits, not only from supplying workers for the profitable canneries and mills of the Fraser Valley, but also from supplying goods to their workers. Many of the merchants who imported rice and other goods from China were also major suppliers to Chinese communities and workers across British Columbia and western Canada.

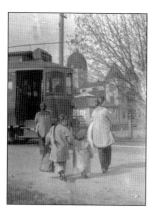

This informal snapshot, c. 1906, captures traditionally dressed Chinese women and children rushing to board a streetcar on First Street outside the gates of Queen's Park and the Provincial Exhibition grounds.

IHP 2644-030

In the summer of 1907, an insidious rise in racism began to threaten the very existence of New Westminster's Chinatown. The Vancouver Trades and Labour Council, not content to work within the constraints of the political process, formed the Asian Exclusion League, whose mandate was to lobby the Canadian government to restrict Asian immigration. The league separated from the Trades and Labour Council and began to directly incite hostilities between racist Caucasians and the Chinese community. At a mass meeting on September 7, an anti-Asiatic mob took its anger to the street and stormed Vancouver's Chinatown and Japantown, breaking windows and causing mass hysteria. Many of Vancouver's Chinese merchants sent their wives and children directly to the safety of the Royal City's Chinatown.

At the time, New Westminster remained peaceful:

Apart from a heavy influx of Japanese and Chinese from Vancouver and continued preparations among the residents of Chinatown against any attempt on the part of hoodlums to interfere with their liberty there is little to record with regard to the anti-Asiatic agitation situation. There is

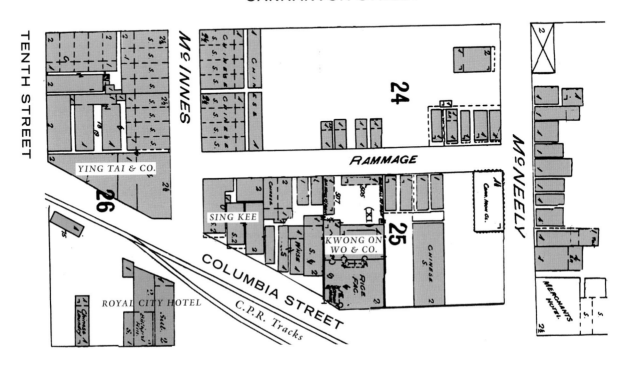

CARNARVON STREET

TENTH STREET

MᶜINNES

MᶜNEELY

24

RAMMAGE

25

26

YING TAI & CO.

SING KEE

KWONG ON
WO & CO.

ROYAL CITY HOTEL

COLUMBIA STREET

C.P.R. Tracks

MERCHANTS
HOTEL

This 1907 map of the heart of Chinatown shows the crowded
buildings and hidden alleys that helped gamblers escape
police raids.

Courtesy of Jim Wolf

43

20 *Daily News*, "Asiatics Arrive from Vancouver," September 11, 1907, p. 1.

little fear that there will be any demonstration locally, the promoters of the proposed anti-Asiatic league have decided that the time for the formation of such an organization is inopportune. In any case the police would not permit a demonstration or parade of any kind.[20]

A few New Westminster residents formed their own Asian Exclusion League, and several prominent, influential residents were elected to serve on the league's executive. These included the city's building inspector, Thomas Turnbull, who served as president, and J.D. Taylor, owner and editor of the *British Columbian* newspaper, who was elected as the group's secretary. On October 28, the group prepared for a rally. When asked by reporters whether it was the intention of the league to start an anti-Asiatic parade, "they were rather non-committal but added if such would do the cause any benefit that it would not be discouraged."[21]

21 *British Columbian Weekly*, "Asian Exclusion League to be formed in this City," October 15, 1907, p. 1.

The rally only drew 100 supporters and no riot occurred. However, both Thomas Turnbull, in his role as the city's building inspector, and J.D. Taylor, as the *British Columbian*'s editor, would continue to have a significant and negative impact on the future of the city's Chinatown.

It was shortly after a local branch of the Asiatic Exclusion League formed that Chinatown began to be singled out in the *British Columbian* as a grave fire hazard for the city. In February 1912 the City's "Fire Limits" were extended to include Chinatown, thereby giving city council the authority to order owners to demolish existing buildings considered a fire threat. Thomas Turnbull and the fire chief authored a report for city council that stated: "On the block surrounded by McNeely, Blackie, Columbia and Carnarvon streets, there is a mass of congested buildings that are a menace to surrounding property."[22] The report essentially recommended the outright removal of the city's Chinatown through demolition by order of city council. But council chose not take immediate action for demolition, but instead convinced property owners to deal with fire hazards and demolish shacks that were unsafe.

22 *British Columbian Weekly*, "Must be Removed," April 30, 1912, p. 14.

Council knew that "the swamp," which included Chinatown, was slowly being transformed by its industrial growth. In 1911 the *British Columbian*, in an editorial sanctioned by J.D. Taylor, profiled the area's transformation and promoted the removal of Chinatown:

The development of the west end of the city as a wholesale and manufacturing centre is most marked. Where a few years ago was to be found a morass and a few tumble down shacks, inhabited by a few unhealthy looking Asiatics, are to be found today stately wholesale blocks and busy factories, and it does not require a great amount of prophetic vision to see in the not too distant future still further development along that line.[23]

23 *British Columbian Weekly*, "The West End Metamorphosed," August 1, 1911, p. 18.

At this time many in the Chinese community were preoccupied with the exciting politics of their homeland, that is, the 1911 revolution in China against the ruling Qing Dynasty. Within Chinese-Canadian communities a new organization emerged known as the Kuomintang, or Chinese Nationalist League, which supported the revolution's leader, Sun Yat-sen. Sun had visited British Columbia on fundraising tours in 1910 and 1911, drawing huge crowds of supporters. He even visited New Westminster, taking an automobile tour of the city with supporter Koo Dock, the owner of Sing On, a prominent local textile merchant and underwear manufacturer.

The local branch of the Chinese Nationalist League was founded in 1911, establishing its headquarters in the former residence of the Cash family at the corner of Carnarvon and Eighth streets. Its support for the revolution and the republic of China was strong: meetings were frequent and fundraising efforts were successful. It was claimed that this was the first Chinese-Canadian community group to send financial aid—which it did in February 1911—to its compatriots.

Wealthy Chinese merchants were not only involved in their homeland's political battles, but also in their own investments and improvements to the Chinatown district. In 1910 merchant Sing Kee headed a fundraising drive for the local branch of the Chinese Freemasons to build a new hall on Carnarvon Street near McInnes Street. The building and its meeting hall was furnished with elaborate decorations obtained from China and cost $5,000. It was opened with a formal ceremony on the night of a full moon.[24]

24 *Daily Columbian*, "Chinese Masons to Open Hall," August 27, 1910, p. 1.

Law A. Soong built a $3,000 store-and-apartment building (later known as the Melbourne Hotel), on Twelfth Street near Columbia. Law A. Soong also announced a partnership with Lee Ching to build a $50,000 commercial structure on Eighth Street and Carnarvon, this one with five storeys. In addition,

in partnership with Law A. Chong, Law A. Soong financed a substantial addition to the existing Ying Tai store at Columbia and Tenth streets.

At the corner of Carnarvon and McInnes streets, owner Lee Din had local architect J.F. Watson draw up plans for a five-storey block, with seven stores, to be built at a cost of $50,000. However, only the first two storeys were completed by 1913, when a recession brought to a close a spectacular era of growth for British Columbia. It appears that most of these ambitious construction plans, although announced in the local press, were scaled back or not completed because of the economic recession that began that year.

A FIRE TRAP IN THE HEART OF THE CITY {1914-1939}

The First World War set off a chain of events that would lead to the wholesale collapse of the local economy and marked the beginning of the decline of Yi Fao. From 1914 to 1916, unemployment was severe in the city, likely mirroring the estimated 80 percent of the Chinese community in Vancouver who were out of work. The immigration rate from China to BC dropped from an annual average of 3,500 to 1,000 or less. Many Chinese people decided to return to China, further adding to Yi Fao's decline.

In New Westminster, the resource bases of lumber, agriculture and fishing were devastated by local changes to the economy following the declaration of war. British Columbia's population declined significantly as men joined the military; some immigrants returned to England to join family and regiments there. Without a labour force, sawmills and manufacturing plants closed, throwing the entire, already fragile economy of the Pacific Coast region into turmoil. Compounding the situation, the salmon-canning industry also suffered substantial losses through mismanagement and overfishing.

Unemployment among Chinese people was exacerbated when New Westminster's city council, in reaction to the onset of the economic recession, passed a resolution in 1913 stating that the city would not employ Chinese labourers or purchase any goods from firms using Chinese labour.

Chinese contract workers found sympathy within the Chinese Labour Association, formed in Vancouver in 1916. Enabled by the poor local economy, employers had begun to exploit immigrant workers—including the Chinese—

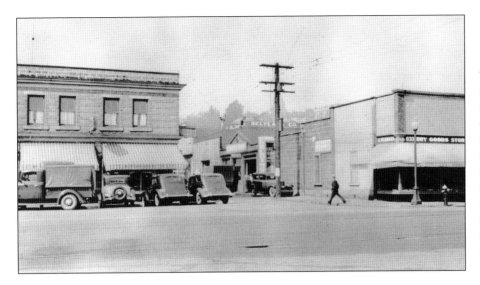

This view of the intersection of Columbia and McNeely streets, c. 1935, shows Chinatown during its transformation from a shopping district (as seen in the Japanese-owned stores, Nishiguchi and Fujiwara, facing Columbia), to a car-oriented, service-industry district that included such companies as Westminster Welding on McNeely Street.
IHP 4409

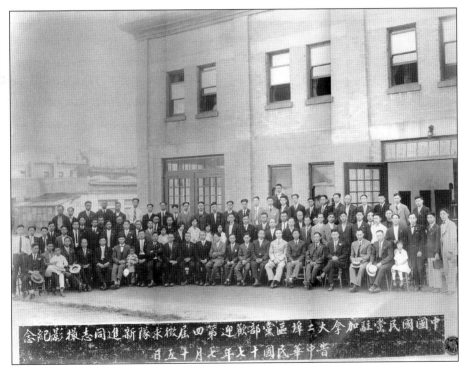

念紀影撮志同進新隊求徵屆四第迎歡部黨區埠三大拿加駐黨民國國中
當中華民國十七年七月十五日

The fourth convention of New Westminster's Chinese Nationalist League poses for this group portrait on July 15, 1928, in front of the New Westminster Fire Hall at Carnarvon and McNeely streets.
W.H. Chow Studio photograph, IHP 8056

by paying low wages. Desperate but determined workers in local sawmills went on strike in 1918 in a bid to have their workdays shortened from 10 hours to 8, to match those of Caucasian workers.

Despite these attempts to protect themselves from exploitation, however, many labourers simply found no employment. To make matters worse, rice, the staple of the Chinese diet, was becoming an expensive commodity due to the wartime reduction in overseas shipping. Local Chinese merchants pooled funds to feed the destitute with rice gruel, served as a single midday meal every afternoon at two o'clock.

New Westminster's Chinese community also faced the city's continued efforts to transform the western end of its downtown area into an industrial warehouse and supply district. There were legitimate concerns that some of the old wooden buildings, owned by both Chinese and Caucasians, were a fire hazard and needed to be demolished or upgraded. In 1914 city council again received reports from the city's building inspector, Thomas Turnbull, that condemned the core buildings forming Chinatown. Rather than order the outright demolition of structures during difficult economic times, council sought agreements with the owners to limit the life of the wooden buildings deemed fire hazards. As a result the Ying, Tai & Company block was slated for demolition in 1917, and the Sing Kee block was to be torn down in 1918. However, the grim economic conditions of the war years led property owners to request delays in the demolition orders so that they could wait for improved economic conditions before replacing the blocks.

Finally, in 1919, the provincial fire marshall, J.A. Thomas, conducted a tour of inspection and announced that the Chinatown district was a "fire trap in the heart of the city."[25] Thomas had the power to order the demolition of all the blocks deemed hazardous. Instead, he focused initially on the block bounded by Columbia, McNeely, Carnarvon and Blackie streets, which contained many Chinese laundries. The clearance of this area would create an open space, preventing a fire in Chinatown from being spread by westerly winds to the downtown business district. To its credit, council reviewed all of the options available to owners, but in the end acknowledged the fire marshall's authority to order demolition.

25 *British Columbian,* "Fire Trap In The Heart of the City, " July 26, 1919, p. 1

Another tour of inspection with Thomas Turnbull, in 1920, led to the issuance of further demolition orders for another 14 buildings, most in the core of Chinatown. In August 1921, when a fire damaged the commercial block owned by Lee Din at the corner of Tenth and Carnarvon, the real threat of a calamitous fire was finally taken seriously.

The call for demolition of the city's Chinatown coincided with another threat to the very existence of Chinese communities in Canada. The Chinese Immigration Act, 1923 (known among Chinese-Canadians as the Chinese Exclusion Act), which all but outlawed immigrants from China, was introduced in the Dominion parliament by New Westminster's own representative, W.G. McQuarrie. New Westminster's city council supported him in the resolution, which called for the complete exclusion of all Asians. McQuarrie's resolution passed, effectively prohibiting Chinese emigration to Canada until 1947, when it was repealed. The new law had the effect of limiting the growth of the Chinese community by not allowing families to reunite and by making it illegal for single Chinese men to bring potential wives to Canada from China. Over time a "bachelor society" of unmarried men developed, a group that would define the character of the New Westminster's small Chinatown in its final years.

Many Chinese property owners did not have the resources to fight the demolition orders. The economic ravages of the war years and the dramatic slide in the regional Chinese population had left many property owners with little or no source of income; their storefronts and tenements were rapidly becoming empty. Other property owners, primarily wealthy merchants, responded to the demolition orders by creating new buildings or undertaking repairs. Ying, Tai & Company and Sing Kee, under threat of demolition for almost a decade, repaired their "ancient" wooden buildings and so managed to survive, and even thrive.[26]

Yuen Sing relocated his general store from a block on McInnes Street that was threatened with demolition to a new brick block, at Columbia and McNeely streets, owned by a Mr. Wong and paid for by Hong Kong investors. It and a new McInnes Street block, also funded with overseas investment, joined the venerable Kwong On Wo & Co. building, giving what was left of Chinatown some sense of permanence in the 1920s.

26 *British Columbian*, "Gas Station to Replace Old City Building," May 21, 1935, p. 1.

City council also began implementing a plan to relocate Columbia Street and the railway tracks to better serve the new wharves and docks then under construction. This vision would result in the opening of the Pacific Coast Terminals in 1929, and the completion of the long-awaited transformation of the western part of the city into a modern shipping and industrial district. The scheme included the demolition of the old, decrepit Royal City Hotel (originally named the Cleveland Hotel), which had stood at the corner of McInnes and Columbia streets, to make room for a new, expanded road.

In 1928 council purchased land that had been cleared of Chinese businesses to improve the city's downtown and civic services. The city's Number One Fire Hall was moved from its downtown location at city hall to a new concrete-and-brick structure at Carnarvon and Blackie streets, occupying a portion of the block that had been cleared as a fire break in 1919 to protect downtown from the potential threat of a Chinatown fire. The determination of council to deconstruct Chinatown during this period was reflected in a newspaper article reporting that "the feeling around the city hall is that with a drive against old buildings in full swing, with many coming down and others slated for discard . . . a second list of condemned buildings is in course of preparation . . . [and] will deal with buildings in what is loosely known as Chinatown."[27]

The destruction of the city's once-vibrant Chinatown through council's policies and the economic decline of the Chinese community are poorly documented in local newspapers, which by this time rarely reported any substantial information on either the businesses or the people of Chinatown. Only a few of the original Chinese residents of the city have left a record of their memories. Chung Koo, born in 1909 above his father's tailor shop, Sing On, remembered well his much-loved home in the heart of a lively Chinatown and witnessed its decline to the point of collapse.[28] As a young boy he wandered though what seemed like a ghost town, discovering many old buildings in various states of disrepair, including the former Chinese Reform Association hall, its floor littered with papers and its walls hung with hundreds if not thousands of framed photographs of past presidents and officials.

In the 1931 census, New Westminster's Chinese population had dropped to 561 from 792 in 1921. Chung Koo watched successful stores and thriving

27 *British Columbian*, "Old Project Is Discussed," August 16, 1922.

28 Jim Wolf, personal interview with Chung Koo, 1985.

restaurants close, while other businesses were moved between blocks as demolition advanced. One of these was a popular Chinese restaurant named Chee Wah Hing Chop Suey House, known for its mouth-watering mooncakes and noodles. It was located on Ramage Street in a two-storey wooden block. The restaurant was on the second floor of the block and was served by a downstairs kitchen and an efficient dumb waiter that sent delicious, steaming dinners up and took dirty dishes back down.

In the 1920s, the restaurant closed and was replaced by a Chinese grocery store. The new immigrants running the store hoped to make their new business a success, but did not account for the economic decline in Chinatown. Succulent roast ducks hung in the windows for weeks, waiting for non-existent buyers, then remained hanging rancid for months after the store closed down. The ducks were finally put to good use starting morning fires in local woodstoves.

Faced with the loss of Chinese customers, Chinese merchants and businesses tried to increase their sales to the Caucasian community. The most lucrative small businesses were run by Chinese vegetable peddlers who drove their wagons or carried shoulder baskets throughout the residential areas of the city and district. Chung Koo remembered that over 10 of the horse-drawn wagons would be driven by the vegetable peddlers out of Chinatown every morning. The wagons would wind slowly up the steep Eighth Street hill, often pausing as the horses grew tired from the climb. Although they were later able to afford trucks to replace their horses, by the mid-1920s vegetable peddlers' businesses were gradually made redundant by the more successful modern Chinese greengrocers, who moved to Columbia Street's main business district as Chinatown was demolished. Chung Koo recalls that the first small storefront, only 10 feet wide, was opened by Lum Him Dot in 1925. Overwhelmed with customers, Lum Him Dot was soon joined by several other businesses, all vying for the vegetable trade with the housewives of the city.

While the rest of Chinatown withered, other Chinese businesses, many masquerading as general stores, thrived through under-the-counter illegal sales of wine and whiskey. In 1919, for example, the Sun Kun Wo Company

on Carnarvon Street was charged with the illegal importation of 177 cases of liquor disguised as nut oil. Pioneer merchant Sing Kee was also caught selling liquor out of his grocery store. Chung Koo remembers the saga of poor Sing Kee, in which local police were tipped about his stash of Chinese whiskey, hidden in a second-floor storeroom. His secret was discovered when the weight of the 700 cases began to collapse the floor above the ceiling of his store. His assertion that the whiskey was for personal use did not convince the judge, who found him guilty.

Despite being outlawed by federal statute in 1908, opium was still available in Chinatown for "medicinal" purposes. Some local Chinese sought to assist those who wanted to quit using this addictive and damaging drug, so they formed a society for this purpose. Chinese Merchant Kwang Tu was one of the society's members and imported medicinal herbs into BC from China that were said to cure the habit. The society even petitioned city council to outlaw the sale of all opium in the city in 1908. However, Kwong On Wo continued to manufacture opium and sell it under a special drugstore licence issued to it by the city. However, the licence stipulated that the company's many regular customers needed to smoke the opium on the premises, so Kwong On Wo built little cots in upstairs rooms where its opium customers could recline and smoke their purchases.

Notwithstanding the laws of the Dominion of Canada and licences of the city, the drug was available practically everywhere in Chinatown, and no real efforts were made to stop Chinatown bachelors from enjoying "their puff." Chung Koo was told as a boy that some local policemen on the Chinatown beat were often paid cash by wealthy Chinese merchants to turn a blind eye and ignore their illegal businesses. It was said that if you didn't pay the police, then you could not blame them for raiding your store.

Illegal gambling also formed an important business for Chinatown merchants, who set up secret gambling rooms in their business blocks or empty tenements. Chung Koo reminisced about the little store run by Lee Man that had a secret room at the back that was a "clubhouse," or fan tan parlour, where many bachelors spent their leisure time gambling. Lee Man was arrested in 1914. As a newspaper reported:

Chief Bradshaw and his merry men descended on his McInnes Street gambling house ... The police completely fooled the crafty lookout man and made their entrance through the roof and interrupted a fan tan game going on full swing ... Two doors taken from the premises were several inches thick and arranged with an ingenious network of bolts and bars, with springs operated by cords which allowed the doors to slam and automatically lock, the instant an alarm is sounded.[29]

The officials also confiscated 10 clubs that, it was asserted at trial, were intended to be used on the police. Chinatown residents had given nicknames to individual policemen who were particularly ruthless in their pursuit of gamblers. Chung Koo remembers that New Westminster police constable Sid Bass was known as "hooknose"; he was widely respected as a great gambling-hall raider who wielded a battering ram to break in. Another well-known raider was Sergeant Milne, or "tall-man," who had no qualms about fighting fist to fist with any gambler. On one occasion, Chung Koo remembers, a fight took place in the middle of the street.

29 *British Columbian*, "Raid Den in Chinatown," November 26, 1914, p. 1.

The proximity of Vancouver's Chinatown prompted many gaming house operators to work closely together to avoid police raids. If the police in either city were cracking down, the games were shifted to the other "safe" city. Wealthy Vancouver players would often be driven by chauffeurs to New Westminster in limousines so they wouldn't have to miss out on a "hot game."

The demolition or closure of the remaining three Chinese general stores signalled the last days of Chinatown. Chinese families, especially those with children, were beginning to relocate to other neighbourhoods away from the unwholesome atmosphere of the rapidly decaying Chinatown. The area's remaining Chinese population was predominantly old bachelors, Chinese immigrant workers without wives or children in Canada who were either too poor to return home to China or did not wish to relocate from their chosen homes in the Royal City.

Council's dream of creating a huge wholesale distribution centre was finally coming true, thanks in large measure to the popularity of the automobile. Trapp Motors was quick to purchase the Sing Kee block at McInnes and Columbia streets after it was ordered demolished in 1929, and build on the site

After the old Chinatown was demolished, the Riverside Apartments, on Royal Avenue at 11th Street, served as the new location for Chinatown's apartments and stores in the 1930s. In this 1946 photo, the sign and flagpoles on the second storey above the Chong Sing Grocery Company store mark the Chinese Nationalist League meeting hall. The store next door was occupied by Japanese families and businesses.

Cloyde Draper photographer, IHP 2244

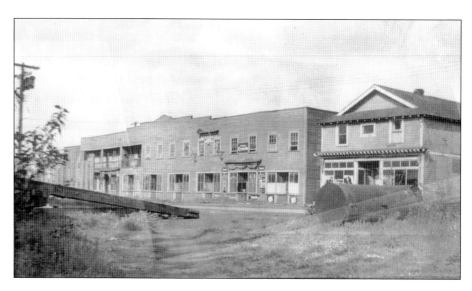

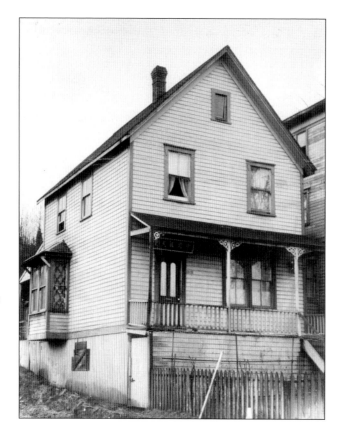

After the demolition of the Riverside Apartments in 1948, the Chinese Nationalist League purchased this house (seen here c. 1949), which served as their headquarters until the league disbanded officially in 1979.

NWPL 1848

a stylish concrete showroom and repair centre. Kwong On Wo finally closed its doors when its brick block was declared a fire hazard. The owner, Chung Yuen, sold the site to Fogg Motors, which undertook extensive remodelling of the structure to create its own modern car showroom. Finally, in 1935, Law Soong, "the third and last of the old-time pioneer Chinese merchants," sold the Ying, Tai building at Columbia and McInnes streets to the Standard Oil Company, which demolished the structure and built a gas station.

A NEW BEGINNING {1940-1980}

The demolition of old Chinatown left the remaining Chinese bachelors of the city, still located in the old Chinatown area, with no choice but to relocate as buildings were destroyed. In 1941 New Westminster's Chinese population dropped to only 400. Many chose to move to Vancouver's Chinatown, while others with connections in the Royal City decided to create a third Chinatown on Royal Avenue at Eleventh Street. Here, a 1912 tenement building known as the Riverside Apartments became a place for displaced Chinese and Japanese stores, and the Chinese Nationalist League. Apartments above the stores served as homes that were equal to or better than the ones in Chinatown for displaced bachelors. The community's important associations, such as the Chinese Benevolent Association and its hospital, or "Old Man's Home," which served as a convalescent home for invalid bachelors, and the Freemasons Lodge, continued to operate in their old locations.

In 1947, as a result of hard lobbying by Chinese-Canadians, the disastrous Chinese Immigration Act of 1923 was repealed, allowing new immigrants to enter the country and families to reunite. Also in that year, the BC legislature finally granted the vote to Chinese-Canadians. It was a new beginning for the Canadian-born generations of the Chinese community.

Chinese families moved to new homes throughout New Westminster, integrating with the city's population rather than being confined to what some referred to as the "ghetto" that was Chinatown. In some cases families moved to apartments above businesses aimed to serve the wider community. A few Chinese restaurants opened downtown and catered to residents who had discovered that chop suey was delicious. Over time, the last vestiges of

Chinatown, which had been reduced to the few squalid apartments occupied by the remaining bachelors, disappeared. The Riverside Apartments building was demolished in 1948, removing the last of Chinatown's residences and stores from the city.

By the 1970s, the only two remaining remnants of the Royal City's once lively and colourful Chinatown were the Chinese Nationalist League's building on Royal Avenue, the Chinese Benevolent Association's building on Victoria Street (which, as noted, had been used as a hospital and a convalescent home for elderly Chinese bachelors), and a Chinese school and meeting hall.

In 1979, however, both the Nationalist League and the Benevolent Association, which had been inactive for some time, disbanded. The directors of the CBA closed the doors on this chapter of the city's history by graciously donating their old hall and its property to the citizens of New Westminster as thanks for the tax-free status the association had enjoyed for years. Regrettably, the CBA building was demolished by the city in 1980, without any real concern for its significant heritage value or its vital connection to a cultural community that had significantly shaped the early history of the Royal City. The building's loss, however, did not seem to matter much to New Westminster's ever-resilient and proud Chinese community. The descendants of Yi Fao's founding families moved forward into a new era, one that finally brought the equality they had always sought and deserved.

Law

NEW WESTMINSTER HAD TWO FOUNDING FAMILIES NAMED LAW. EACH arrived at different times, but both Laws helped to establish and operate one of Yi Fao's longest-running businesses, Ying, Tai & Company. Established in 1889, the business moved to three different locations, lasted for approximately 60 years and was managed by two generations of Laws.

Law Hong Fung and his brother, whose name is unknown, were the first Laws to arrive in Canada. Both came from Tung Soong village in China's Guangdong Province in the early 1880s, in search of gold. According to Law family history, the brothers quickly made their fortunes in British Columbia. After they were financially established, they returned to China and helped their younger brother, Law Hong Tim, immigrate to Canada, leaving behind his wife and his young son, Law Chong.

With financial assistance, Law Hong Tim opened and managed Ying, Tai & Company on the purchased land at the corner of Tenth and Carnarvon streets in "the swamp." It was there that the company's two-level store-and-apartment block was completed in 1889. In addition to importing and wholesaling Chinese goods, including groceries, dry goods, clothing, blankets, boots and shoes, Ying, Tai & Company provided service as a labour contractor—its most lucrative enterprise.

The founding member of the second Law family, Law A. Yam, helped with the business' establishment. It is unclear when Law A. Yam arrived in the area, but his crucial role in Ying, Tai & Company is certain. Under the guidance of Law A. Yam and Law Hong Tim, Ying, Tai & Company grew into a significant business that established the Laws as important members of New Westminster's Chinese community.

One of the Laws' main jobs was to act as middlemen between new

Law Hong Tim, founder of New Westminster's Ying, Tai & Company, c. 1890.

Photo courtesy of Gail Yip

Law Yum Chong, son of Law Hong Tim, and business partner of Law Soong, 1948.

Photo courtesy of Gail Yip

immigrants desperate for jobs and employers who were looking for workers. They also offered immigrant men housing and meals in exchange for a percentage of their wages. Ying, Tai was known to have contracted labourers for many established sawmills and shingle mills along the Fraser River, including the large Royal City Mills, which was located on New Westminster's waterfront and owned by lumber baron John Hendry.

With the business up and running, the Law families began expanding as family members arrived from China. The city's tax assessment rolls for 1892 show 15 members of the two Law families and 60 immigrant workers were living in the apartments above the Ying, Tai & Company store.

In 1887 Law Hong Tim's wife had travelled with their son, Law Yum Chong, to New Westminster. However, she had stayed for a only short time because she could not tolerate British Columbia's climate, which was colder than what she had been used to back home. Her arrival and hasty departure were possible due to a financial advantage that most Chinese women of the time did not have. Although it is uncertain whether or not Law Chong escorted his mother home to China, immigration documents state that he returned to Canada in 1902 aboard the *Empress of India*.

My dad's generation never knew their grandfather. He went back to China. His daughter, my great-aunt, was born here, but my great-grandmother didn't like it here in New Westminster. I think a lot of them find it too cold here because China is somewhat tropical. In the 1891 census my great-aunt was five months old. I don't know how long they lived here, but they went back to China and then after that, my great-grandfather went back to visit because they had two more sons.

GAIL YIP ~ LAW CHONG'S GRANDDAUGHTER/HERBERT (YEE) LAW'S DAUGHTER

Law A. Yam's younger brother, Law Soong, was born in 1879 in the Soon Duck village of Guangdong Province. Law Soong came to New Westminster in 1899 at the age of 19 with his uncle, whose name is not known, to work at Ying, Tai & Company, which had grown over a decade to become one of the most successful Chinese businesses in the Fraser Valley. After being given

private tutelage from Mrs. Hill, Law Soong learned English and was quickly immersed into the business of Ying, Tai & Company.

Law Soong's arrival occurred at a significant time in the company's history. The original Ying, Tai & Company building at Tenth and Carnarvon streets had just been destroyed during New Westminster's Great Fire of 1898. The financial strength of the company was clearly demonstrated when the Law partners were able to purchase land and build a larger three-storey building at the more prominent corner of Columbia and McInnes streets. (It was eventually given the address 901 Columbia Street).

Law Soong, second manager of Ying, Tai & Company, c. 1930.
Photo courtesy of Gwen Wong

Law Hong Tim and Law A. Yam's success and status as wealthy Chinese merchants and entrepreneurs earned them respect in the city's Chinese community, resulting in leading positions in the local branch of the Chinese Reform Association. The Laws' wealth allowed both men the freedom to return to China as they wished. In the early 1900s, Law A. Yam returned to China permanently, leaving Law Soong to assume his role as manager. After Law Yam's death in 1909, Law Soong inherited his brother's share in Ying, Tai & Company, making him the first member of the second generation of Laws to operate the family business.

Law Hong Tim returned frequently for visits to his homeland and reunions with his wife, ensuring that his family continued to grow, eventually comprising four sons and one daughter. Law Hong Tim returned to China for the last time around 1912, where he died at approximately age 55, leaving the business to his eldest son.

Law Chong's wife, Chan You Jook, c. 1920s.
Photo courtesy of George Quan

Law Chong had been to New Westminster many times as a boy. He was educated here and would have grown up knowing Law Soong and the business the two would later run. Before his father's death, Law Chong entered into an arranged marriage to Chan You Jook in China around 1900. With Law Chong travelling between the two countries, the couple had two boys before deciding to move the family to New Westminster in 1913. Law Chong and his wife later went on to have more children, giving them a total of seven, six boys and a girl: Fong, Chuck, Yee (Herbert), Lum, Kee, Winnifred and Ronald[1]. Producing a male child was of the utmost importance to a Chinese family, and the number of boys produced by the pair would have made any traditional Chinese family proud.

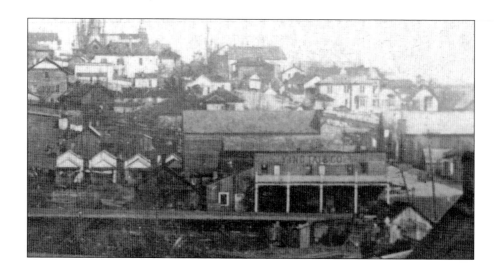

First Ying, Tai & Company
building at 47 Tenth Street,
New Westminster, c. 1890.
IHP3085

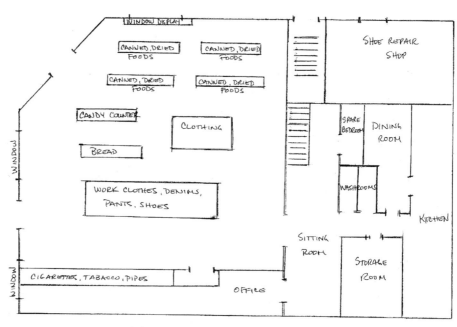

Inside the Ying, Tai building at
901 Columbia Street. The image
is drawn as remembered by
Dora Chan in 2006.

60

My grandmother and grandfather were married in China around 1900. My grandmother at the time worked in a silk factory. My grandfather then made two more trips to Canada, once in 1902 and again in 1908, before he moved here permanently in 1913. On his final trip, my grandmother came with him, along with their two oldest sons, Fong and Chuck. Sometime during January 1913 and December 1915 my grandmother gave birth to two daughters and one son, but none survived. My father, Yee Mon Law [Herbert] was born on December 23, 1916. Dad was their fourth son and first child born in Canada to survive.

My grandfather was educated in New Westminster and could read and write in both languages [English and Chinese]. My grandmother could only speak Chinese. As a child I never remember her speaking to me. I can't even recall the sound of her voice.

GAIL YIP

In 1904 Law Soong married Chow Shee[1] in China, and she returned with him to Canada. The couple had eight children: Betsey, June, Mae, Jean, Quon, Betty, Dora and Theda. Unlike the other Law family, Law Soong and his wife did not have a surviving male heir: Chow Shee did give birth to a boy, but he was stillborn. The couple was so desperate for a son that they had given their seventh daughter, Dora, a Chinese name: Yan Tai, which loosely translated means "luring of a son" in the hopes that the next child would be a boy. But their eighth child was another girl, Theda. After that, Dora took on the role of her father's son.

With both Law families expanding, the second Ying, Tai building was altered to accommodate the vast number of people living under one roof. The business was set up so that the first floor served as a retail store, selling goods such as produce, food, clothing and wholesale materials. The second floor housed the Law Soong family, and the third floor was the residence of the Law Chong family. A one-storey section at the back of the building served as communal bunkhouse for contract workers. It included a kitchen and dining hall, and company cooks served meals to the workers.

1 "Shee" is a form of address for a wife. Chow is her maiden name (wives kept their maiden names).

He [Law Soong], along with his cousin [Law Chong] more or less ran the Chinatown labour vocation. What they did was obtain contracts built from the likes of so many Chinese workers. They would house these workers in some place in a bunkhouse. They would provide them with room and board. They would get a cut of the income for these people that work under them. I don't know what kind of vocation you would call that. They dealt with Chinese workers, as consequence they made pretty good money. That was their business, Law Soong and his cousin.

CHONG (JOHN) QUAN ~ BROTHER OF GEORGE QUAN/HUSBAND OF LAW SOONG'S GRANDDAUGHTER, VIVIAN

In 1935 Ying, Tai & Company relocated for the last time. With the demolition and dislocation of New Westminster's Chinatown, the company faced financial pressures and sold its land to Standard Oil Company Ltd. The landmark Ying, Tai & Company building was torn down to make way for a new service station.

The Law families packed up what they could take from the old business and moved to the Melbourne Hotel at 120 Twelfth Street. Law Soong had erected the building in 1912 to serve as a four-storey wooden block with apartments above a small commercial storefront. The two Law families and a smaller group of contract labourers moved into the apartments, and the bottom floor provided storage for wholesale foods.

George Quan (a friend of Law Chong's son Ronald),[2] who later married Law Soong's granddaughter, Vivian, remembers sneaking into the storage area to get a treat:

It was a building that was a former store, maybe a general store originally. Then Ying Tai took it over when they had to move from McInnes. They took it over, but they never operated it as a store. We used to go in there, Ronald and I. They operated the camp for the single workers. They lived in the third floor, like a bunkhouse. They stored their flour, their sugar, things like that inside the store, but it wasn't a store because it was all boarded up. We used to sneak in there and get a scoop full of brown sugar. Brown sugar was like candy, so we used to raid the supplies.

2 Adjusting to life in Canada meant learning the language and adapting to the lifestyle of the greater society. Some traditions were kept, while others were altered or abandoned. For example, the traditional Chinese form of address was surname first, followed by first name. The Chinese settlers in New Westminster maintained this convention. Children in the next generation, however, were given both Chinese and English names, and they adopted the convention of using surname last.

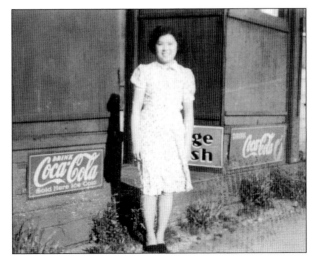

Dora Law outside the third Ying, Tai building at 120 Twelfth Street, 1939. Note the wooden covers over the windows.

Photo courtesy of Dora Law

Peering from the second-floor corner window of the Ying, Tai building are (from left) Jean, Betty and Chow Shee Law, 1939.

Photo courtesy of Dora Law

Second Ying, Tai building, 901 Columbia Street, New Westminster, c. 1930s.

Photo courtesy of Mae Lee

Law Soong and Law Chong operated the numerous extensions of the Ying, Tai business. Many family members remember the farm known as Ying Tai Ranch, first located in Surrey. Workers tilled vegetable fields and managed a large pig and chicken operation on approximately 100 acres of land. The ranch supplied the kitchen in the Ying, Tai & Company bunkhouse with fresh vegetables, meat and eggs to feed the Law families and the contract workers. These items, along with wholesale goods imported from China, were also distributed to buyers along the British Columbia coast, as far north as Bella Bella and Bella Coola.

Ying, Tai had three farms at three different times at three different locations. Their first farm was located off Scott Road. Their second farm was in Maillardville on Schoolhouse Road across from Millside School. The farm was rented from a World War I army vet named Brehault. This farm was about 88 acres and was called Ying, Tai Ranch. They [Ying, Tai] owned the farm that was located on Annacis Island because in the 1950s they sold it to the Grosvenor Laing Company, which is owned by the Duke of Westminster. Dad remembers going to that farm because they had a little tugboat that would pick them up at the foot of Eighth Street. The farms produced vegetables for the labourers who boarded at Ying, Tai.

GAIL YIP

I used to work on the farm. We used to fool around with the truck. That's how I learned how to drive. I worked at the farm when I was nine, ten years old. Pull the weeds out. Tomatoes [were] the toughest, it sticks in your hand. Sticks and smells all day. Sticks to your fingers. It was thick. I remember that. I don't like it. Just go on the weekend, that's all.

In those days you don't have chicken. They wanted us to go and help pull the weeds out [at the farm]. They pick us up at 7:30 in the morning. We work there. We have chicken [as] something special for lunch or dinner. I see all the chicken around the farm. They have a [pen]; it was quite big. We had no chicken at home. So I asked the man that ran the farm, "Can I have chicken to bring home to my mom, to all my sisters?" "You catch one, you bring it home." I run around and I caught one.

I kill it too, myself. You have to kill it yourself. So I asked him, "How's that?" He said, "You hold the two legs here, the two wings, pull the head back then pull some of the feathers off. Use your knife and go through." I did it! I wanted it for my dad, for my mom. First time I ever caught a chicken. I cry just thinking about it.

DORA CHAN ~ LAW SOONG'S DAUGHTER

Given the many ventures associated with Ying, Tai, running the business took a lot of time, effort and help. Not having a son to rely on, Law Soong found a way to get the assistance he so desperately needed. In the typical traditional Chinese family, girls were expected to work with their mothers, doing household chores, and not get involved in business. Accordingly, the daughters in the Law families were rarely allowed to go down into the Ying, Tai store. The one exception was Dora, who, in her role as a "son," spent many hours helping to operate the business. Dora adored her father; she often sacrificed her own social life and risked her personal safety so that he could have a night off or enjoy a game of mah-jong.

Working at night frequently frightened Dora. Caucasian boys would sometimes come by and bang on the front windows or the side door to scare her. A few times they even broke the glass, which led the Laws to protect the windows with wooden covers at night.

All the others, my cousins, they go out and play, they want to go out and bowl, stuff like that. Nobody wants to watch the store. My dad used to stay behind and I want my dad to have some fun, play Mah Jong, go to Vancouver. So I said, "Dad, you go, I'll watch the store." I didn't tell him I'm afraid because I want my dad to go.

This is Ying, Tai here. This is on Twelfth Street. I have to carry them up [wooden boards] and cover the window. Some bad boys, they don't like the Chinese, they used to kick and bang on the windows. That's why we covered the windows of the store because they bang them all the time. Friday nights and Saturday nights, that's when I watched the store myself.

DORA CHAN

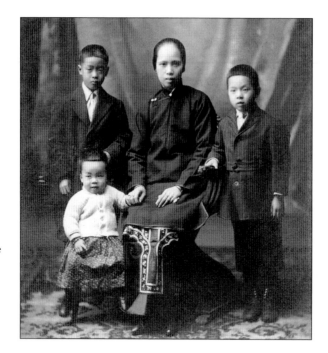

Clockwise from bottom left:
Herbert (Yee), Fong, Chan You
Jook and Chuck Law. Herbert
(Yee) admired the Law Soong
girls so greatly that he wore one
of their outfits for this photo,
c. 1919.
Photo from studio of Paul Louis
Okamura, New Westminster, courtesy
of Gail Yip

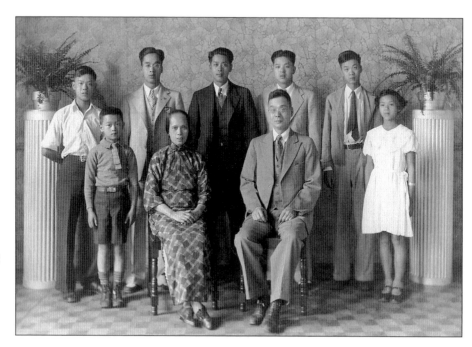

Law Chong family, c. 1935.
Back row, from left: Kee, Herbert
(Yee), Fong, Chuck, Lum and
Winnie. Front row: Ronald,
Chan Yoo Jook and Law Chong.
Photo courtesy of Gail Yip

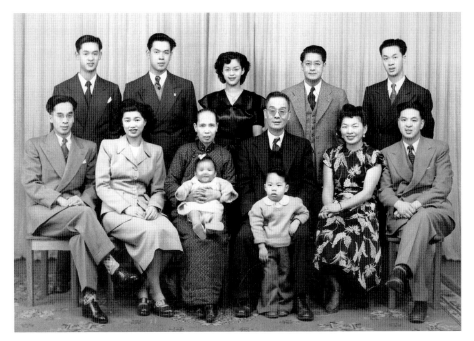

Law Chong family, November 28, 1948. Back row, from left: Ronald, Kee, Winnie, Fong and Lum. Front row, from left: Herbert (Yee), Jean (Herbert's wife), Chan You Jook with granddaughter Christina in her arms, Law Chong with grandson Chester in front of him, Doris (Chuck's wife) and Chuck. The children belong to Chuck and Doris.

Photo courtesy of Gail Yip

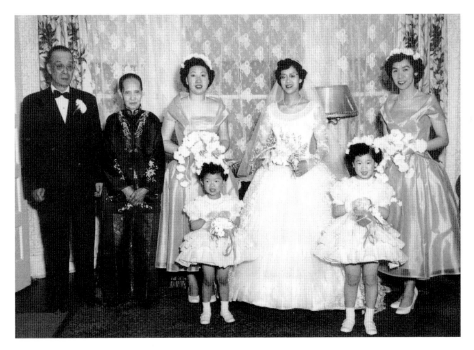

The wedding of Winnie Law and Bill Wong at the Law family home, 25 E. Sixth Avenue, Vancouver, May 1955. From left: Law Chong and his wife, Chan You Jook, May Chow (née Wong), Winnie Law, Theda Law. The flower girls are Darlena Law (daughter of Chuck Law) on the left and Carolyn Law (oldest daughter of Herbert Law) on the right. (Bill Wong is not pictured.)

Photo courtesy of Gail Yip

In addition to working for Ying, Tai, Dora worked at Save Right groceries on Twentieth Street (a store owned by Law Soong) and she was also the first woman to work at a local shingle mill. Because Ying, Tai provided the mill with contract labourers, it was also their responsibility to replace injured or missing workers. When a worker was injured one day, and it was Law Soong's duty to find a replacement, Dora helped her father out by volunteering to package shingles in the mill that day.

Dora got her chance to step outside the Ying, Tai business through her involvement with the Daughters of China. This association was formed by a group of New Westminster's Chinese women in 1941 to raise money to send to China during the Second World War. The group received funds in various ways, including door-to-door solicitation, evening dances and fashion shows at the Hollywood Bowl on the corner of Eighth Street and Carnarvon. Anyone from the area could come to the events as long as they paid the admission fee. The group even entered an elaborate float in the New Westminster's May Day parades.

There was a Hollywood Bowl. It's almost on the corner of Eighth Street and Carnarvon. It's a rather large building. It's still there. Hollywood Bowl they put on a few shows for fundraising and I think they were selling Chinese bonds to help the war effort. That drew some of the families and the ladies together. They would put on things like fashion shows, lion dance, Kung Fu demonstrations, stuff like that, just to raise money for the community and the war effort.

GEORGE QUAN

3 George Quan: My mother was taught to sign her name by Chong, and we concluded that she adopted the first name "See" because it sounded like her given name, which was Quan Chow Shee. "See" was easier to learn for her.

Apparently, most Chinese women in the community took part in the group, with the older generation looking after administrative duties and the younger girls acting as representatives at social events. One of the founding members was Mrs. See[3] Quan (mother of Chong and George Quan), but the role of president rotated from year to year, allowing various girls, including Dora Law, to run the group. Female members from the Law, Lee, Quan and Shiu families were all involved in various aspects of the organization.

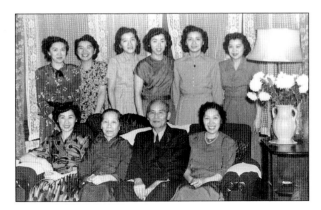

The Law Soong family, c. 1940. Front row, from left: June, Chow Shee, Law Soong, Betsey. Back row, from left: Mae, Jean, Betty, Theda, Quon, Dora.

Photo courtesy of Gwen Wong

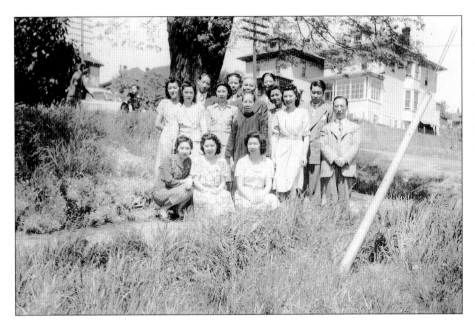

The Law Soong family, May 1947. Kneeling, from left: Betsey, Dora and Theda. Middle row, from left: Mae, June, Chow Shee, Quon, Jean and Willam Chu. Back row, from left: Betty, James Lee, Ed Lee, Law Soong, Ben Yip, Henry Sung.

Photo courtesy of Dora Chan

There's a war going on back in China. We weren't supposed to spend money. We sent our money back to our village. To help relatives, they have no money. We put on parties. We put on dance or a fashion show for the younger girls. I think we put [fashion shows] on two or three times, and dances. You buy a dollar ticket. Fashion show would be the intermission at the dance. Anybody could come buy a ticket. So lots of Caucasian people come, the young men because maybe they have no girlfriend. They have to buy tickets, so we make money. We send that money back to China.

DORA CHAN

The fashion shows were spectacular exhibitions of Chinese costumes borrowed from the Vancouver Cantonese Opera in Shanghai Alley.

We have to borrow them [Chinese dresses]. Borrow them from actresses, from Vancouver, they have an opera there. From Shanghai Alley, there used to be opera theatre there. I go to visit my sister, the second sister, help her with the baby. Every weekend I go over there and watch the opera in Chinese song. I don't understand it, but they had nice clothes. That's where we borrowed them.

DORA CHAN

These events and fundraisers did not benefit war-torn China only: Dora Law met her future husband, Leslie Chan, at one of the dances she helped organize. In fact, Dora had met Leslie at the shingle mill the day she was there to help. While she did not remember him, he had remembered her.

We met at a dance. We take turns for president ever two years, Daughters of China. It was that year, my turn. I have to put on games before we start the dance, so I have musical chairs. That day something happened, I didn't want to go that night. I was mad at somebody and my sister Jean wouldn't go unless I go. Anyways, I went. There's one chair that nobody sits on, I don't know from [the] three who I'm supposed to choose for that chair before I start the game. So I ask, "Hey, Les." After that he took me home, and we courted, then marriage.

70

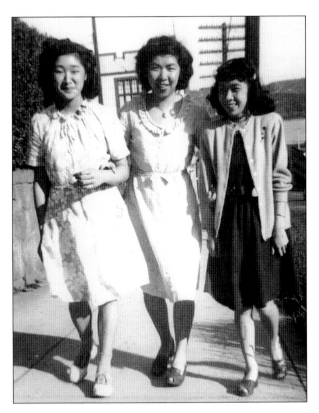

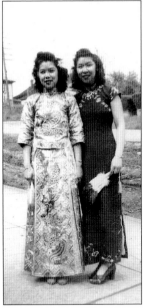

Dora Law, left, and her younger sister, Theda Law, displaying their outfits for May Day, May 18, 1945.

Photo courtesy of Dora Law

From left: Denise Quan, Theda Law and Vivian Chu walking up Eighth Street in New Westminster, c. 1950s.

Photo courtesy of Dora Law

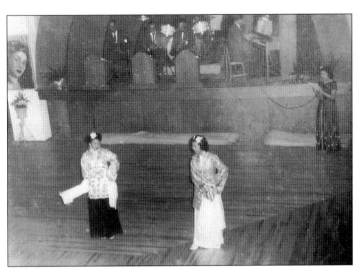

The Chinese fashion show held at the Hollywood Bowl, June 1948. The two women are wearing Cantonese opera costumes from the Vancouver Chinese opera.

Photo courtesy of Dora Chan

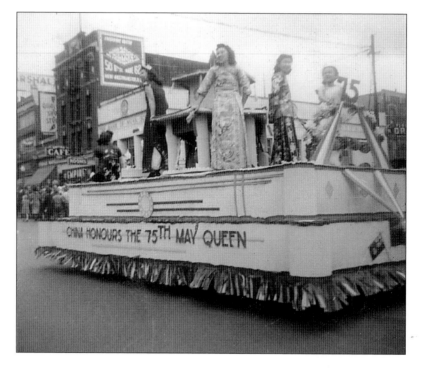

The Daughters of China float in New Westminster's May Day celebration. From left: Theda Law, Dora Law, Kate Quan, unidentified female, May 18, 1945.

Photo courtesy of Dora Chan

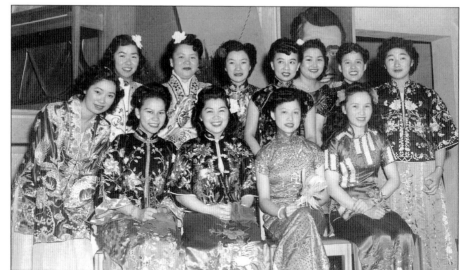

The Chinese fashion show at the Hollywood Bowl, June 1948. This was a fundraiser for flood relief that raised $403, which was presented to the fund by Elizabeth Shiu, treasurer of the Daughters of China. Back row, from left: Theda Law, Elizabeth Shiu, Alice Fong, Esther Shiu, Gwen Quan, Rosemary Lee and Denise Quan. Front row: Kate Quan, Queenie Fong, Dora Law, Pearl Lee and Alice Kong.

Photo courtesy of Dora Chan

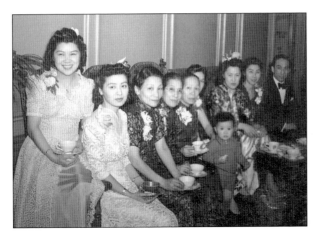

Quon Law's wedding, March 13, 1943. From left: Dora Law, Quon Law Sung, Elena Wong Sung, Mrs. Chu, Chow Shee Law (Law Soong's wife), Mae Law Lee, Mrs. Chung Law, June Law Chu and Bill Chu. The little boy is Norman Lee. Photo courtesy of Dora Chan

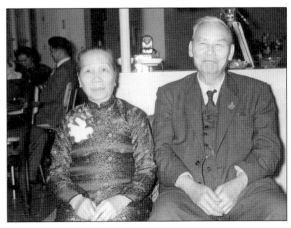

Chow Shee and Law Soong celebrating their wedding anniversary, c. 1950s.
Photo courtesy of Dora Chan

"I'll take you home, I'll help you fix up the chairs, put them away." Ok, that's nice of him. So he told the other two boys that he was going to take me home. I went outside and there's an old truck with an apple box for me to sit [on]. It's so funny. I thought a nice car was going to take me home.

DORA CHAN

A marriage had been arranged between Leslie and Dora's sister, Jean, but as Jean had her heart set on someone else and Leslie had his eye on Dora, the wedding never happened. Dora and Leslie left the dance together that night, began a courtship and later married. Having already viewed Leslie as a match for one of his daughter's, Law Soong approved Leslie's relationship with Dora.

Dora married when she was 28, later than most women of her generation. The delay was due to her devotion to her father and her work in the family business, which left little time for social events or dating. But even though she had made sacrifices, Dora's ability to step outside of traditional gender roles resulted in a close relationship with her father, making it all worthwhile.

Her relationship with Law Soong did not include much talking; most of the communication between Dora and her father was done through Dora's mother. If Law Soong was upset or had something to say to the girls, he would say it through his wife. One of the few times that Law Soong ever directly spoke to Dora was on the eve of her wedding, when he asked her if she was happy and if she no longer wished to stay at home to continue working for the family. Having Law Soong speak directly to her about an important issue was something extremely memorable for Dora.

He [Law Soong] don't talk to girls, to us. Whatever he doesn't like, he tell to Mom, Mom tells, "Dad don't want people to go out and Dad don't want to do this." Dad doesn't talk to us. That's why I thought I was special. I remember that night before I married, he tell me, "You want to marry that family? That boy?" Dad liked him. He was supposed to marry one of my sisters. They were matched.

I was surprised because he wanted to talk to me, he never talked to the other sisters. He talked to me before I got married.

DORA CHAN

In 1940, the Laws were compelled by financial pressures to sell the Melbourne Hotel, which was immediately demolished to make way for the Terminal Hotel. With the loss of this building and the end of Ying, Tai & Company, the two Law families went their separate ways. The Law Soong family stayed in New Westminster, while the Law Chong family moved to Vancouver. Law Soong died in 1957 and Law Chong passed away in 1964. After this time, the families led separate lives and ran independent businesses, but the story of their partnership in Ying, Tai binds them together in history.

Lee

LEE CHING GREW UP IN GUANGDONG PROVINCE. AFTER WORKING FOR the Chinese branch of the Kwong On Wo business in Hong Kong, Lee was sent abroad at the age of 21 to manage the company's store that opened in New Westminster in 1887. Kwong On Wo was originally located on Front Street at Lytton Square, but after the 1898 fire it was relocated, along with the rest of Chinatown, to "the swamp." Its owners built its landmark business block at 98 Columbia Street. Kwong On Wo was one of the area's most prominent Chinese businesses, and the only Chinese-run store built of brick. It was a wholesale establishment carrying Chinese groceries along with fabrics, clothing, pots and pans. It also contracted and housed labourers for various positions, including, one assumes, the construction of the Canadian Pacific Railway.

In the general store, my grandfather was the payroll clerk or master for the railway. The people used to come in and collect their pay at Kwong On Wo. Basically, that was his job. Kwong On Wo was owned by a very large company in China. This was not the only one.

BARBARA TUAI ~ LEE CHING AND WONG SHEE'S GRANDDAUGHTER/
FANNIE LEE'S DAUGHTER

While working for Kwong On Wo, Lee Ching became was one of the most respected businessmen in the area and had strong roots in the Chinese community.

He [Lee Ching] was a very intelligent man. From what I understand, when he came over he could speak Latin as well. Very good-looking man, very clean. Every morning he would go out and sweep the porch, without fail. He always dressed

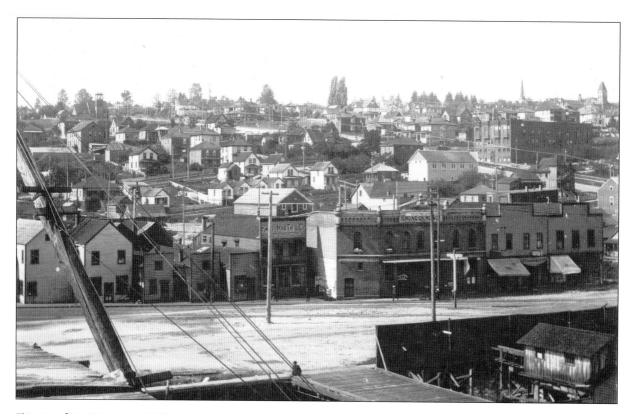

This view of New Westminster's Chinatown district in 1909 shows the many prosperous stores lining Columbia Street between McInnes and McNeely streets. The prominent brick block of Kwong On Wo and Company was the most impressive structure built in the district following the Great Fire of 1909.

Philip Timms photograph, IHP 0342

very, very reverently. He always wore a tie, a suit, a jacket and slacks. He was a very well-respected man. He had the patience of Job. I couldn't have asked for a better grandfather.

BARBARA TUAI

Lee Ching represented Kwong On Wo at the first official meeting of the Chinese Benevolent Association in 1915 and was instrumental in helping the organization grow. Lee Ching's family members believe that he even helped Yip Sang, one of Vancouver's leading Chinese businessmen and pioneers, get his start. Yip Sang worked at Kwong On Wo in New Westminster for a short time before establishing himself in Vancouver's Chinatown as one of the leading Chinese businessmen, politicians and community members.

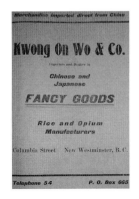

Kwong On Wo advertisement from the 1903 *Columbian* supplement.

From what I understood, Yip Sang did work for my grandfather. I don't know for how long or anything. Then he [Yip Sang] moved to Vancouver, he started his own business, but I understand he was in the same [business], contracting and hiring for the railway.

BARBARA TUAI

Lee Ching arrived in New Westminster as a businessman, but eventually wanted to build a family, so he sent for his two wives in China. It is unclear whether Lee Ching had met these women prior to their arrival or if their trip to Canada was part of the arranged marriage. Because multiple marriages were illegal in Canada, Lee had to be creative to get the women into the country. Women had greater difficulties coming to Canada, as it was men who were desired as inexpensive labourers. According to Lee Ching's daughter, Fannie, each woman was escorted by her brother, and the older first wife, Quan Shee, claimed the younger second wife, Wong Shee, as her daughter. Thus four people came to the country at the same time, posing as relatives to one another. This ruse seemed to fool immigration, but Wong Shee worried about the legalities of the relationship for most of her life.

The young Lee Ching on the
deck of a ship, c. 1900s.
Photo courtesy of Fannie Lee

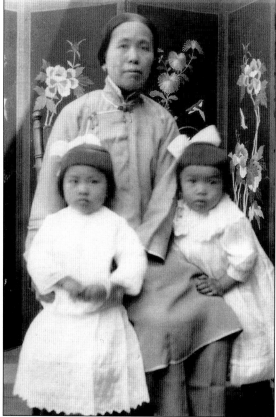

Quan Shee with Lee Ching's
first-born children, Hannah
(on the left) and Fannie, c. 1913.
Photo courtesy of Fannie Lee

Lee Ching and his two wives, c. 1940s. From left: Wong Shee, Lee Ching and Quan Shee. Note Quan Shee's bound feet.
Photo courtesy of Fannie Lee

Wong Shee and Lee Ching, c. 1940.
Photo courtesy of Fannie Lee

This goes back to such a long time ago when the Asians had the head tax and everybody was afraid of illegal people coming in. Lee Ching came over when he was approximately 21 years of age. At the approximate age of 40 he sent for his wife, dai poh, who was born in the same village as him. They were about the same age. She came over with her brother. At the same time, my pohbe, *the second wife, came as well. She was also from the same village. She was approximately 21 years younger than dai poh. My dai poh claimed her as her daughter. Along with my pohbe came her older brother. These facts came to life when I talked to my mother [Fannie].*

Now my grandmother, she was wonderful. We called her "Pohbe." We would run home after school and we would always say in Chinese, "What's there to eat?" She would always say, "Macaloni." That means macaroni: "macaloni." She would use the soup bones to make the broth, and there would be vegetables in it. That could go for days; you just keep adding "macaloni." It was wonderful. You just slurp back the macaroni. She was an excellent cook. I learned all my Chinese and all my cooking from her. She used to be so patient.

BARBARA TUAI

Lee Ching's two wives arrived some time around 1910, and not long after, both were pregnant. In 1911, Quan Shee gave birth to her only child, Hannah, and Wong Shee delivered her first child, Fannie. In the years that followed, Wong Shee produced four more children: Lin, Daniel, Lily and Richard.

Living as a traditional Chinese family with more than one wife meant adopting the traditional roles that accompanied these positions. In a Chinese family, a woman's rank was based on her position within a marriage. Wife number one held more status than wife number two, and so on. In some cases, later wives were only "added" to serve the first wife. Lee Ching's first wife, Quan Shee, had bound feet (a sign of higher status), making her incapable of completing the household tasks associated with a wife's role. In order to have a wife who could look after his family, Lee Ching married the younger Wong Shee. Although in so many ways Wong Shee was the more important wife in the Lee family in terms of tasks and obligations, she was seen and treated as a woman of lesser status than wife number one.

The Lee Ching family, c. 1920. From left: Fannie, Wong Shee with Lily, Lin, Lee Ching, Daniel, Quan Shee and Hannah.

Photo courtesy of Clifford Wong

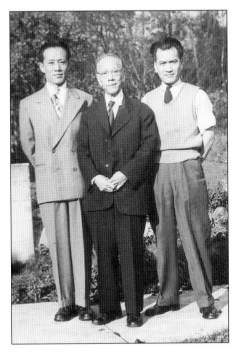

Education was important to Lee Ching, and he helped support his children Lin and Daniel while they were getting their university education. The two graduated from the University of British Columbia with degrees in engineering. From what Barbara remembers, her uncles were only allowed to take mining engineering because of their ethnicity. From left: Lin, Lee Ching and Daniel, c. 1950s.

Photo courtesy of Fannie Lee

Being a second wife in Canada not only meant that you were of lower status within the family, it also meant that you did not have any status within the wider Western society. Wong Shee always feared that she would be sent home to China, even though Canadians were not fully aware of or interested in Chinese traditions at that time. Wong Shee worried that she had no legal rights in Canada because her marriage was not recognized, and she tried to find ways to keep the nature of the family a secret.

My grandmother didn't like to go out too much because she was always afraid that someone was going to send her back to China because she was the second wife. There was always that fear in those days for the second wives. They were not to be seen and heard. We always seemed to have a lot of garbage for the garbage man and you don't like to put out too much stuff, so she'd put extra stuff out there but she'd [also] put a six pack of beer. She'd peek from behind the curtains and the garbage men knew she was there if there was extra stuff, they'd wave to her and say "thank you." They'd take the beer and her extra garbage.

BARBARA TUAI

The different status of the two wives inevitably led to an imbalance in the Lee family. Even though Hannah and Fannie were born in the same year and were both daughters of Lee Ching, Hannah—as the daughter of wife number one—had greater status and privilege than her sister. From what Fannie can recall, she attended Central Elementary School on and off until grade three, when she was needed at home full time to help the family. As the daughter of the second wife, Fannie was expected to stay at home to help her mom cook for the workers. Later, when Wong Shee went to work on a farm, it was Fannie's duty to look after her siblings. Hannah did not have any of these responsibilities.

Hannah doesn't do anything, because Hannah's the older daughter, so I do all the cooking. Hannah doesn't do a thing. Years ago I did [resent that], but after I thought mother always get after me so I'm ok after that. If I make a fuss, mother gets heck for it.

I do a lot of cooking. I do more cooking when I was young than older because

82

mother had to cook for 10 or 20 people sometimes. They work for the company and whoever come in from out of town. They'd stay over the weekend and you'd have to cook for all of them.

FANNIE LEE ~ LEE CHING AND WONG SHEE'S DAUGHTER

Fannie's daughter, Barbara Tuai, remembers how in old photographs Hannah would often have a bow in her hair while Fannie did not. Hannah also had the privilege of attending Chinese school. However, even though Fannie was treated differently from her sister, she was no less loved or cared for by her father. Lee Ching dedicated many nights to teaching Fannie how to read and write Chinese. Even though Fannie did not have the same privilege of attending Chinese school like Hannah, Lee Ching still recognized that all of his children needed an education.

My dad teach me at home because I didn't have time to go, got to work. Every night, everybody play outside, I have to come in by 7 o'clock [for a] two-hour Chinese [lesson] from Dad. Then I learn all that read and write and all that. Can't remember a thing now.

FANNIE LEE

Because Mom worked, my grandfather used to bathe us, get us ready for bed and we always had Chinese school. Mom's younger brother Dick and my brother and sister, Pat, Kenny and myself, there was the four of us. We'd have Chinese school upstairs on the top floor; it was like the attic. He had his little writing desk and he would teach us to read and write, he would grade according to our skills. If you were really good you'd get three ice cream cones. If you were not bad, you got two and if you were just good he always gave you one. There was never [just] a cone, there was always one scoop on there. I remember that.

BARBARA TUAI

From left: Hannah, Lin, Daniel and Fannie Lee standing outside the Columbia Street Kwong On Wo, c. 1915.

Photo courtesy of Fannie Lee

Fannie Lee sitting outside the doors of Kwong On Wo, c. 1928, not long before the store closed.

Photo courtesy of Fannie Lee

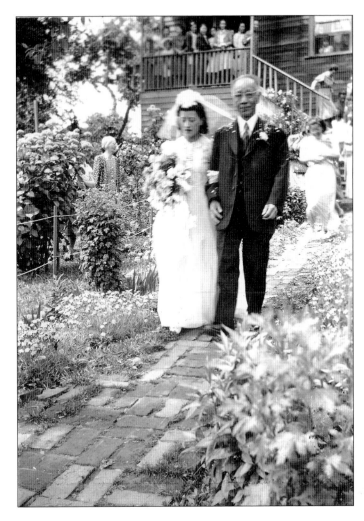

Hannah Lee and her father, Lee Ching, walking through his garden on the day of Hannah's wedding to Bill Wong, June 10, 1940.

Photo courtesy of Clifford Wong

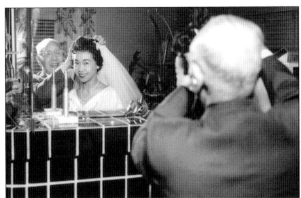

Lee Ching helping his granddaughter, Barbara, on her wedding day to Kim Tuai, February 22, 1957.

Photo courtesy of Fannie Lee

Running a business was popular in Chinatown; if you did not have an actual store, then you ran a farm or sold products door to door. Many people did not want to hire Chinese workers, so those who had the money to do so often chose to work for themselves. This mentality was very much a part of the Lee Ching family. Not only did Lee Ching manage Kwong On Wo, he also owned a charcoal kiln in Surrey, where charcoal was manufactured and sold to such places as Buckerfield's warehouse, which was located on New Westminster's downtown wharves.

After Kwong On Wo closed in 1929 and Lee Ching's children had grown up, a couple of them continued the practice of running a family business. A part of Yi Fao's later history was the Pagoda Restaurant, which opened in 1953 at 41 Mackenzie Street, between Clarkson and Carnarvon. Fannie's sister, Lily, and her husband, Park Wing, owned the Chinese restaurant until it closed on Easter Monday in 1968. This business was a family institution; if you were part of the Lee family, you worked in the restaurant. Fannie's daughters, Brenda and Barbara, along with Lily's children, Cedric, Lila, Bob and Patty, all remember that working for the family was just par for the course. You did not complain, you just did it because it was expected of you. Other family members that helped out at the restaurant were Fannie and her son Walter.

We washed dishes, we waitressed, we washed the floor. We did it all . . . It [The Pagoda restaurant] was very North American. Everyone was Caucasian, so it was either number one, number two, number three. Chow mein, fried rice, sweet and sour pork, $2.75, $2.89 with tax. Then they would order prawns on the side.

BRENDA ERLENDSON ~ LEE CHING'S GRANDDAUGHTER/
FANNIE LEE'S DAUGHTER

I did work at the Pagoda. The dining room was upstairs. Downstairs was a couple of tables, but mostly everybody went upstairs. It was a beautiful restaurant because we always had a white tablecloth, it was always a clean white tablecloth. At the end of the evening, you bundled them and threw them down the stairs. It was a nice restaurant. It had a jukebox.

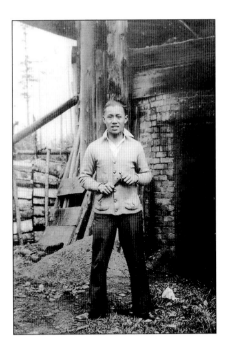

Lin Lee at the family's charcoal kiln in Surrey, c. 1930s.
Photo courtesy of Fannie Lee

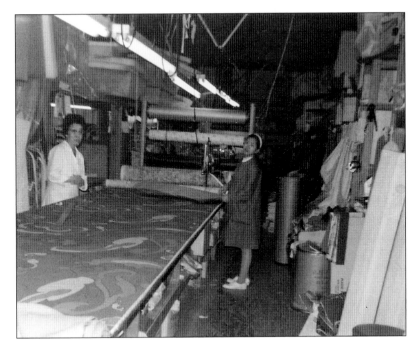

On the right is Adeline Lai working with Fannie Lee at her brother Daniel's business, Westport Manufacturing, c. 1978.
Photo courtesy of Fannie Lee

One of New Westminster's
Chinese food hot spots,
the Pagoda restaurant at 41
Mackenzie Street, c. 1960s.
Photo courtesy of Lila Wing

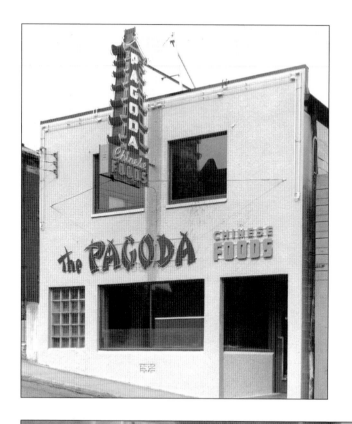

Having fun working in the
kitchen at the Pagoda. Walter
(Dedi) Mark, Fannnie's son, is
in front, with Park Wing at the
back, 1958.
Photo courtesy of Lila Wing

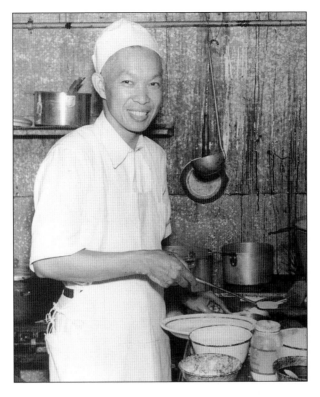

Park Wing preparing food in the Pagoda restaurant, 1958.
Photo courtesy of Lila Wing

Lily Lee taking a break at the counter of the Pagoda, c. 1960s.
Photo courtesy of Lila Wing

I remember going to school on a Friday, then [at] five o'clock going from school right to the restaurant, working till three, four in the morning and working again Saturday! But that was par for the course. We used to make tips. Maybe we were lucky [and] we'd make a dollar a day, because people would only leave 10 or 15 cents—if you were really lucky, someone would leave a quarter! That was a long time ago.

BARBARA TUAI

Another Lee family business, Westport Manufacturing, was created by Fannie's brother, Daniel, to provide local hotels with bedding and drapery. Working alongside Daniel in this venture was Wong Shee, Fannie, brothers Richard and Lin, Barbara's then-husband, Kim Tuai, and Hannah's husband, Bill. Maybe it was because they were immigrants to a new country; maybe it was a matter of trust; or maybe it was that Chinese people were raised to look out for their own. Regardless, a family business was not passed *down* to the family; it was passed *around* the family.

One of the central aspects of the Lee family's life was the celebration of Chinese New Year. For them, as it is for most present-day Chinese families, Chinese New Year is the most important of the traditional Chinese holidays. The celebrations start on the first moon of the new year, and last for 15 days. Everything stops, businesses are shut and people stay home from work. The first week is the most significant, celebrated with visits to friends and family and the exchange of good-luck greetings.

In New Westminster during the early 1900s, all of the businesses in Chinatown closed for the New Year. Fannie Lee remembers the great celebration with fondness. She and her mother, Wong Shee, spent weeks cooking in preparation for the event. Fannie even had a special dress to wear during the season.

Chinese New Year is a big thing too in those days; now it's nothing. We celebrate it for a whole week; eat, drink and everything. Lot of people come into town too. We really celebrate Chinese New Year. It's the only thing Chinese have anyway. Once a year, big deal.

FANNIE LEE

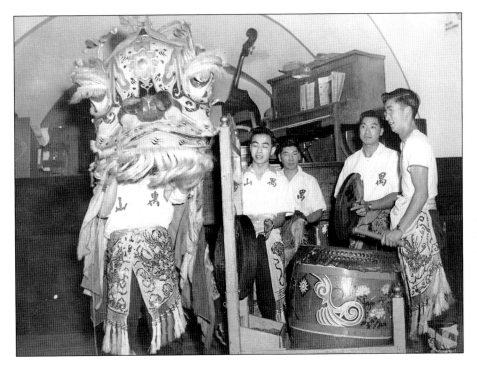

The Lion Dance performed by the Yue Shan Society, part of the fundraiser for China held at the Hollywood Bowl in 1944. From left: Samuel Shiu, Winston Quan, Benny Quan, George Quan (on drum).

Photo courtesy of George Quan

Because Kwong On Wo had a large back-walled garden (the only one in Chinatown), the local Chinese community used to gather there annually to light firecrackers.

Fireworks are big. They go outside in the yard of the store. I remember, everybody comes over because we have huge garden in the back. Everybody brings the fireworks, they're burned there. I remember my brother Lin, he had a rocket in his hand, it blow right in his hand, took his skin right off. So now we put it in the ground.

FANNIE LEE

Fannie also remembers receiving the much anticipated packet of money, a New Year's custom. Red packets containing *lai si* or "lucky money" are traditionally given by married to unmarried people. This event could be quite lucrative for children, as they would receive money from family and family friends. George Quan remembered how he could make enough money over the New Year season to last him almost a full year.

Chinese New Year was very prominent in my mind. They didn't have a whole lot of celebration, it wasn't big enough for [a] Lion dance or anything like that, but they did decorate the stores. Certainly everybody in Chinatown participated to the extent of celebrating Chinese New Year. And that was the biggest event when we were kids. As a matter of fact, that was the greatest source of income for me.

GEORGE QUAN ~ HUSBAND OF LAW SOONG'S GRANDDAUGHTER VIVIAN

During the '50s my uncle Ron always took home movies or scads of photographs whenever there was a family gathering, which was almost every Sunday. [One of] the segment[s] of the film is Chinese New Year, and we are taking turns kowtowing to Grandma before we receive our lucky money. It is really funny when Grandma turns around, waves her hand at us as if to say, "Hurry up; we've got to get through this line as there are so many of you." I find this really surprising as I didn't know my grandma had a comical side.

GAIL YIP ~ LAW CHONG'S GRANDDAUGHTER

Even though Chinese New Year was a highly celebrated occasion in Fannie's youth, that excitement had diminished by the time George was a young boy, some 20 years later when Yi Fao was no longer a vibrant Chinatown.

Quan

QUAN YUEN HOY WAS BORN IN 1876 IN LOO CHOW VILLAGE, SHUN DUK (Shunde) county, near Guangzhou in Guangdong Province. In 1898 Quan Hoy landed in Victoria, British Columbia, with the goal of earning enough money to return to China and settle comfortably there. According to family notes, Quan Hoy returned to China around 1907 to enter into a pre-arranged marriage. Unfortunately, his wife died not long after the union. He then married his second wife, who also took sick and died without producing any children.

Seeking a fresh start, Quan Hoy returned to Victoria to work as an apprentice in a men's tailor shop. While there, he met and married Mark Yin Yong, one of the few eligible Chinese girls in Victoria. This third marriage produced two daughters, Anna (1912) and Gertie (1913). After a bitter end to a business partnership, Quan Hoy and his family returned to China in 1916, intending to start a business and provide a proper Chinese upbringing for the children.

Most Chinese women felt pressured to produce a male heir, and Mark Yin Yong was no exception. When the couple's third child was another girl, Eng Moy, Mark Yin Yong felt unbearable grief at her failure to give birth to a son. Shortly after, she became ill, but before she died, she urged her husband to find a fourth wife, one who might bear him sons.

Quan Hoy married his fourth wife through a pre-arranged marriage. Chow You Han was an independent woman with a well-paying job at a silk factory in her village. Because of the high volume of silk being produced, many women in the area had jobs, and this gave them independence; they had no need to fulfill the traditional female role. Numerous women turned to suicide rather than be forced into a pre-arranged marriage. Chow You Han did not

want to marry, but neither she did want to take her own life. In the end, she chose marriage, and became Mrs. See Quan in 1917 at the young age of 17. Two years later, she gave birth to a son, but the child died two years later.

In search of profitable employment, Quan Hoy returned to Canada with his two daughters, Anna and Gertie, leaving his wife and Eng Moy in China. Unable to find work, he entered another business partnership, this time in a Chinese gambling joint in Victoria. Soon he was making good money, and he decided to send for his wife. She arrived in 1921, but without Eng Moy. The couple stayed in Victoria long enough to produce another son, Chong (John) Quan, and then moved to New Westminster. Quan Hoy quit the gambling business and established a tailor shop at 701 Front Street.

He [Quan Hoy] got his tailoring experience in Victoria, prior to marrying my mother. That was, I think, on his second trip out. He had to find means to provide a living so he apprenticed under a Chinese tailor in Victoria, who taught him the ropes. That's the reason he opened his shop in New Westminster; he knew how to tailor men's clothes.

CHONG (JOHN) QUAN ~ QUAN HOY'S SON

Settling into New Westminster's Chinatown, the Quans were able to survive on the income that the small tailor shop produced. The family grew even larger with the addition of another son, Henny, born in 1924; Jenny, born in 1925; and finally George, in 1928. In the late 1920s, the older girls, Anna and Gertie, married husbands in Vancouver, freeing up a bit more living space in the cramped quarters at the back of the tailor shop.

The onset of the Great Depression devastated Quan Hoy; the already meagre income of his shop was dramatically reduced. With the stress of everyday life mounting, Quan Hoy began to complain about feeling ill; he insisted on returning to China to live, believing his health would recover there.

He had the sickness, I think because things were getting over his head. He didn't have much background besides the tailoring. In those years, during the Depression, there wasn't a lot of business to be had, so I think he was worried sick about that. That's

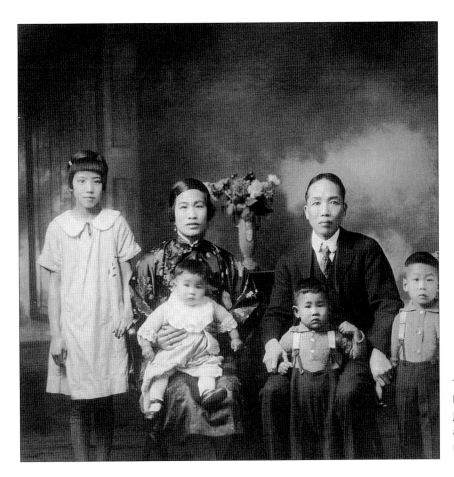

The Quan family, 1926. From left: Gertie, Mrs. See Quan with Jenny, Hoy Quan with Henny and Chong (John).

Photo courtesy of George Quan

when he decided to take the whole family back to China, thinking that conditions of living might be better there. This is in 1929, 1930. So that's why he left the tailor shop, back then. [He went] back to China with the three of us. Unfortunately, he thought he would find a cure for his sickness; that it might be there, but in fact it turned out that he had more problems there. He couldn't find a vocation, a job or something to bring in some money. So within a year of arriving in China, we all came back here. The impetus of that was the fact that my younger brother [Henny], the one after me, took sick with cholera while in China. He was very sick, so my mother convinced my father to get him back to Canada for treatment. He finally agreed, but, unfortunately, my brother died on the ship coming back.

CHONG (JOHN) QUAN

Back in New Westminster in 1932, which was still in the throes of the Depression, Quan Hoy found few employment opportunities, so he opened another small shop for clothing alterations and cleaning in the Dunsmuir Hotel at 46 Eighth Street. The family moved into the small store in the basement of the hotel, which faced Blackie Street. The stress of generating an income to support his family eventually proved too much for Quan Hoy's fragile health, and he died of a stroke in 1935.

We lived on the ground floor because my father had a tailor shop on Eighth Street inside of the hotel. It was one of the storefront hotels. We lived in the back of the shop. I spent about six or seven years in that location. My first recollection was the winter of 1932. I was four years old and I had frostbite very bad on my right foot. I lost a toe because of that. So that was my first recollection of the winters in New Westminster. They were quite severe. Snow was piled high and it was freezing.

GEORGE QUAN ~ QUAN HOY'S SON

We came back and that's when we moved into the Dunsmuir Hotel . . . Of course that didn't bring in very much money. He died in 1935 of a stroke. He had his trouble, health and finance wise. I think the stroke was a result of that, his trials and tribulations.

CHONG (JOHN) QUAN

96

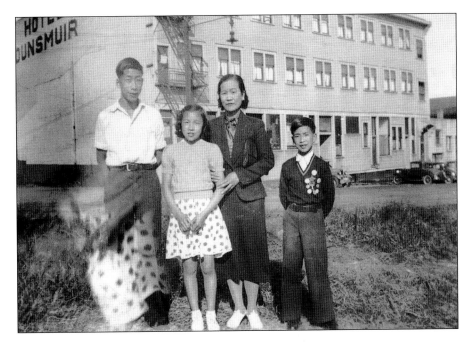

The Quan family, 1935. Chong (John), age 14; Jenny, age 10; Mrs. See Quan and George, age 7. In the background is the rear of the Dunsmuir Hotel at 46 Eighth Street.

Photo courtesy of George Quan

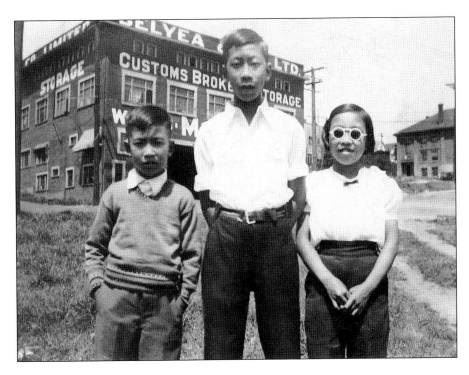

The Quan children on Carnarvon Street in New Westminster in 1934: George, age 6; Chong (John), age 13; Jenny, age 9. The Belyea and Company building is in the background.

Photo courtesy of George Quan

Losing Quan Hoy was a devastating blow to the Quan family; without a father and husband, life changed dramatically for Mrs. See Quan. She was a young woman of 35, faced now with supporting three children on her own. She started working for various companies and proved herself a resourceful entrepreneur, admired for her tenacity in providing for her children through many small business ventures. She worked hard at any job she found, and despite her limited education she was well spoken, well respected and well liked among the people of Chinatown.

She used to sew for one of the companies in New Westminster; the Tong Kee company was her employer. They had a store on Eighth Street. It was a clothing store. Mostly jeans and not fine clothing, but she did a lot of sewing for them. So that's how she had the odd job around town. That's how we survived, on relief and what she could earn until we were old enough to start helping out in the family.

My mother would make these deep-fried cookies that were very crunchy and very tasty. She would make maybe a few dozen of these and I would bring them over to the gambling hall and sell them for five cents each. They didn't have any liquor served in the gambling hall, to my knowledge, but they always had tea and these cookies went very well with tea. So that was part of my job. My mother invented the business and I helped carry it out. That was something I did when I was young too. The gambling hall was a very busy place.

GEORGE QUAN

Naturally, the death of their father also altered the lives of Chong (John), Jenny and George. Each was affected differently, but Chong's everyday life changed the most. He became the man of the family and had to act as such, working alongside his mother at Tong Kee. He had to work after school and on Saturdays while his friends and siblings were off playing. George's life, on the other hand, was a little easier than Chong's. Although it was difficult for him to grow up without a father, he was left with memories of playing and having fun; Chong had few such memories.

98

At that time there was more or less a flourishing Chinatown down on Eleventh Street and Royal Avenue. There was a mini-Chinatown established after the one on McNeely Street. We lived there in an abandoned store. It wasn't very good because my mother was widowed then, she had to go out and do sewing or whatever else to keep us going. I was only 13 when my father passed away. That was the reason why I had to quit Chinese school. George started Chinese school about the same time as me. He was about seven years old at the time. Just after we started Chinese school my dad died, so they yanked me out and put me to work in a Chinese clothing store on Eighth Street, Tong Kee . . . I felt it quite badly when all of my school chums would have the day off after school; have a few hours before suppertime to play while I had to go to the store and work. Saturday was all day, nine o'clock to nine o'clock. I felt a bit hard done by. When you're the oldest of the family, there's not much else. Not much income coming in. I took it.

CHONG (JOHN) QUAN

Despite being widowed at a young age, Mrs. See Quan never remarried. Chong speaks of this as a respectful act: although she attracted her share of male suitors, Mrs. See Quan made her family and the Chinese community her priority.

Who knows what gives a single minority woman the strength to survive in a foreign country with no support and a family to raise? Her children no doubt inspired her, and her strong character was certainly a factor. Whatever the source of her strength, Mrs. See Quan was a determined lady who, according to George, was the rock of the family. She was the family's driving force during the difficult times that they faced during the Great Depression.

Beyond her dedication to her family, Mrs. See Quan also found time to be active in the Chinese community and was instrumental in founding the Daughters of China and the Chinese school at the Chinese Benevolent Association. Having her children educated in Chinese was important to Mrs. See Quan, so she and some of the other mothers got together and in 1942 hired the first teacher, likely Reverend C.C. Shiu.

Of course, many young children did not enjoy having to attend regular school in the day and Chinese school at night. Kids being kids, they wanted

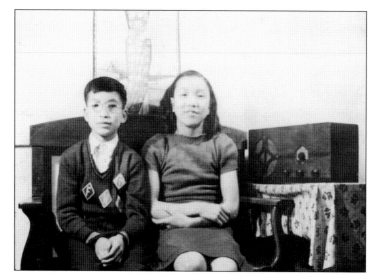

George and Jenny Quan with their first six-tube RCA radio, in their house at Royal Avenue and Eleventh Street, 1937.

Photo courtesy of George Quan

George Quan walking down Columbia Street in New Westminster delivering the *Chinese Daily* newspaper, 1939.

Photo, taken by unknown street photographer, courtesy of George Quan

George and Chong (John) Quan walking down Columbia Street, New Westminster, in front of the Bank of Commerce, 1948.

Photo, taken by an unknown street photographer, courtesy of George Quan

Betsey Law Quan with her daughter, Clarice, and Mrs. See Quan standing in front of what may be the Tong Kee Tailor shop, c. 1950s.

Photo courtesy of George Quan

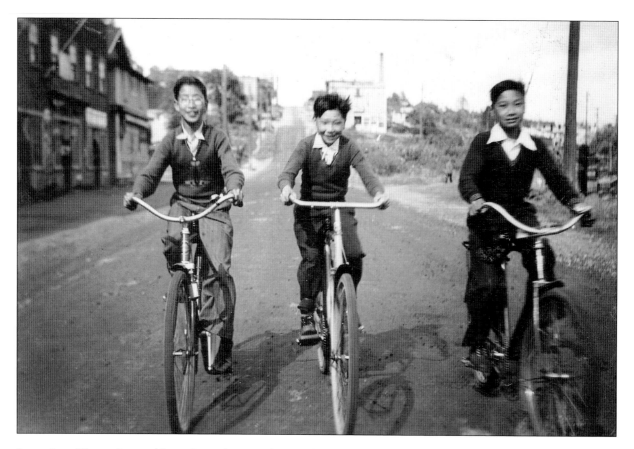

George Quan, Winston Quan and Benny Quan riding west along Royal Avenue in 1942.
On the left are some buildings in the third Chinatown, between Tenth and Eleventh streets.

Ronald Law photo, courtesy of George Quan

Family gathers on a sunny day for a portrait, c. 1940s. Standing are, from left: Tenie Quan from Calgary, Clarice Quan, Mrs. Betsey Law Quan, Mrs. See Quan, Mrs. Law Mun and two unidentified women. The seated children are not identified.

Photo courtesy of George Quan

to play instead of study, and most don't remember what they learned. Some former students recall the school with fondness, others with a bit of remorse.

My mother, along with a few others, thought that the Chinese or the Canadian-Chinese that were born in New Westminster should have some schooling in Chinese language. This started I guess about 1940, shortly after the war . . . The Chinese Benevolent Society [sic] of New Westminster had a large building on Victoria Street. A few of the mothers got together because they were concerned that there was no education in Chinese language at all in New Westminster. They hired a teacher and started the Chinese school in the Benevolent Society building. We went to school there after the regular school, of course. We would go home after three o'clock; we might have a snack and [then] go to the Chinese school, which was only two or three blocks away. We would learn lessons from four o'clock to six. Then we would go home for dinner. That's our routine. We had about an hour and a half to two hours of Chinese language school. That was all right; however, most of the kids that went protested. They went because their mom told them to. They weren't there because they wanted to learn the language, because, after all, we were born in Canada. We were 99 percent Canadian. Still, we respected our parents to the point that we should try and maintain our culture as much as possible. We did learn to read and write basically, but our hearts were never in it. But it was good. The main benefit of Chinese school in those days—I went for about three years—is we got together with the other Chinese kids. As far away as Fraser Mills some of them came after their schooling. They came from Fraser Mills every day on the bus to come to Chinese school. We didn't have that many that could form a strong Chinese school. Maybe about 20, that's about all. But we got to know them quite well. It brought the kids of our generation closer together and that was a great benefit.

GEORGE QUAN

We had a good time. I enjoyed Chinese school. I don't think I ever really not wanted to go. Half-day Saturday was always good too. Half-day Saturday was not Chinese school per se in learning how to read and write, it was making speeches. I guess it was called elocution, or how to stand up in front of people to present

George Quan standing in front of Joe Sing's Plymouth on Royal Avenue, 1939. George remembers going for rides in neighbour Joe's car.

Photo courtesy of George Quan

Three close friends out on one of the local mountains. From left: George Quan, Benny Quan and Ronald Law.

Photo courtesy of George Quan

yourself in an orderly fashion. We always had to prepare a little story that we had to go up and say in Chinese. My grandfather was a wonderful, wonderful man, he was so patient with us, he always helped us prepare our stories. Our stories all came from Aesop's Fables, so they were short and they all had a meaning to them. To be able to say it in Chinese was really quite easy, and it always started, "Once upon a time . . ." We were lucky because a lot of the people there, their parents couldn't take the time to do it, and their Chinese was not as good. It was a struggle for them and it was quite sad. But ours [our stories], we were just out of there, boom, boom: "Okay, can I give another story or speech?" That's what we did on Saturdays, and it was good.

I think he [Reverend Shiu] was from the old school. That's how it was . . .It was only a two-hour class. We had a 15-minute recess, but we would never come back on time. Never! Weren't we terrible? Now that I think about it, I would have sent a note home and let my parents know. It's very frustrating. Considering the span and the age of the group of people too, it was difficult to teach the very young and the older ones.

BARBARA TUAI ~ LEE CHING'S GRANDDAUGHTER

While most of the children were learning Chinese at the CBA, there was at least one exception. Chong remembers starting at the Chinese school, but he soon had to stop so that he could help support his family. He resented having to abandon this opportunity, and out of determination he slowly taught himself everything his sister and brother were learning. Ironically, Chong is the only one in his family who can still write in Chinese.

Attending Chinese school seems to have been a fundamental event in the lives of New Westminster's younger generation in the 1940s. The experience brought them together, creating a strong sense of community. Mrs. See Quan helped to create that sense of community, and her involvement was spoken about with great pride.

If attending Chinese school was fundamental to young people, so too gambling was a huge part of life for Chinese men. Gambling was everywhere in New Westminster. It was entertainment for the single men, who had little

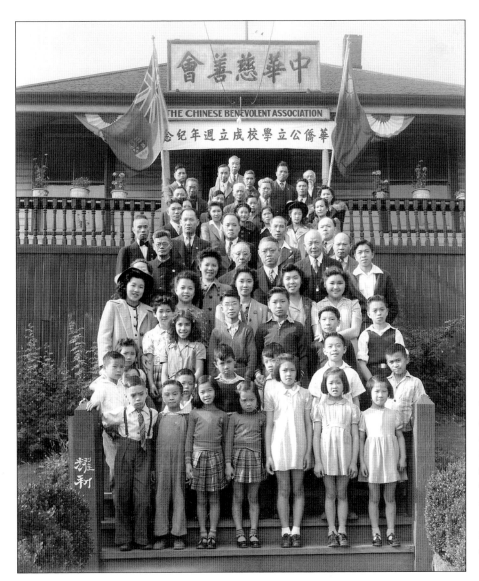

The first class of children at the Chinese Benevolent Association's Chinese School. In addition to the students shown in the photo are the various community members who helped create the school. Members from each of the four families are present on this occasion in 1942.

Photo courtesy of Gwen Wong

The Chinese School at the
Chinese Benevolent Association
in New Westminster, 1944.
Photo courtesy of Dora Chan

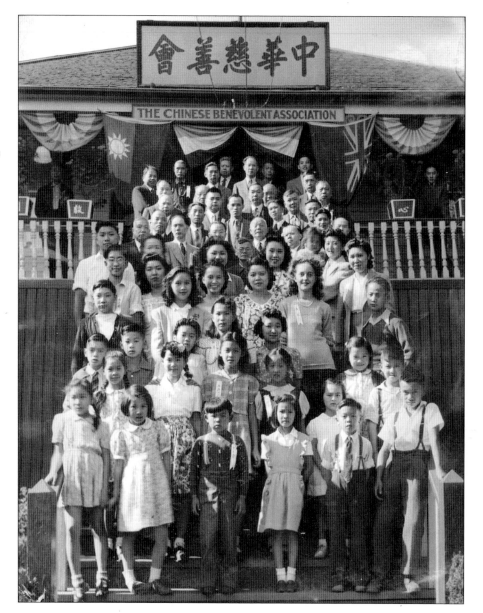

to do after a long day of work and no family to go home to, and it was an opportunity for men to earn extra money quickly. Most immigrant men came to Canada to make their fortune and then return to China. The wages they received, however, were nowhere near rich, and some men were willing to risk what they had to make more.

I remember my father's gambling exploits. Dad opened a store as well. He, with others, opened a gambling club in Victoria. I think they moved to Vancouver for a short while as a means of obtaining income when he was in a down slump. He himself was not much of a gambler; he ended up running an anonymous gambling club. Then eventually, when he married my mother and the family started to come, he couldn't be a gambler anymore. He had to be more legitimate, I guess. He left gambling. He made money gambling, that's for sure, but only as an operator. As you know, Chinese are great gamblers. There's a reason for that too, of course. They'd all be poor and they were hoping to win the motherlode someday by gambling.

CHONG (JOHN) QUAN

Different types of gambling were offered at different locations in the city. Mah-jong, pai gow and fan tan were the most popular games, but other types were also played.

One of New Westminster's most well-known gamblers was Won Joe Quoy. He operated a confectionary store that sold ice cream and served as his storefront for a profitable gambling business. Quoy ran a punchboard game that lured many Chinese men to place their bets. He was also well known as a translator and sports fan, and he had been a successful jockey in the city's early days, when horse races took place on Columbia Street.

Joe Quoy and our store used to be back to back. They sell vegetable, fresh vegetable, fruit and all that. People go in there and buy those tickets [that] they draw. Joe Quoy's have these [punchboards].

FANNIE LEE ~ LEE CHING'S DAUGHTER

He [Joe Quoy] was on Columbia Street. He ran a confectionary store. He was pretty good to us kids, we would go there and buy candies or whatever he did sell. Joe Quoy also ran a [punchboard] numbers racket. I think it was slightly illegal. He wouldn't let the kids openly use the punchboard . . . It's a board like this with maybe a couple hundred holes drilled into it, and all you did was push a pin about the size of a nail; you'd push from the top, then you pushed out, and at the bottom the little number would come out. Based on the number, it was a chance, like the lottery. If you picked the right number, then he'd pay you a certain amount of money. It was an in-house lottery . . . That was his main business, the rest of it was just confectionary, candies and stuff like that . . . He helped the community but maybe he did that for a price, I don't know. He was quite prominent; everybody knew Joe Quoy.

Gambling . . . I do remember that. That was just about a block away from the church. My mother was enterprising; she was widowed by that time and she said, "You know, there's a lot of single guys frequenting the gathering halls." There were, I think, two, but the prominent one was very close to Victoria and where Ninth Street should have been. This was the Gee Goong Tong [Chinese Freemasons].

GEORGE QUAN

Shiu

Reverend Chiu Chung (C.C.) Shiu was born on November 28, 1894, in Lin Yuen, Guangdong Province. Christianity was an integral part of the family, and both C.C. and his older brother, Chiu Yiu (C.Y.), entered the ministry. C.C. graduated in theology from the respected Ling Nan University. In the late 1910s Shiu married his first wife, whose name is unknown, and in 1921 the couple gave birth to their first daughter, Quon Fong Shiu (Elizabeth). Less than two years later, Mrs. Shiu passed away from what is believed to be tuberculosis.

Finding himself a widower, Shiu followed the lead of his brother C.Y., who had taken a position at the Chinese Mission in Vernon, BC, in 1918. C.C. came to Canada in 1924 as a missionary to the Chinese people. Assisted by Dr. S.S. Osterhout and Reverend W.D. Noyes, and sponsored by the Methodist Church, Reverend Shiu was one of the few Chinese people allowed into Canada after the passage of the Oriental Exclusion Act (1923–47).

Reverend Noyes had been a missionary in southern China for 17 years during the early 1900s and had helped many Chinese people enter Canada. Osterhout was the superintendent of Oriental Missions from 1911 to 1939 for the Methodist Church and later for the United Church of Canada; he oversaw the Chinese Mission in New Westminster.

The Methodist Church supported such missions as the Shius' to encourage conversion, believing a Chinese minister could more readily gain the trust of Chinese communities, especially if he could speak the language. Language was of the utmost importance, since most Chinese who came to North America spoke little or no English.

C.C. went first to Nanaimo, where he met and married Julia Jung, who had come to Victoria years earlier to help care for her uncle's wife.

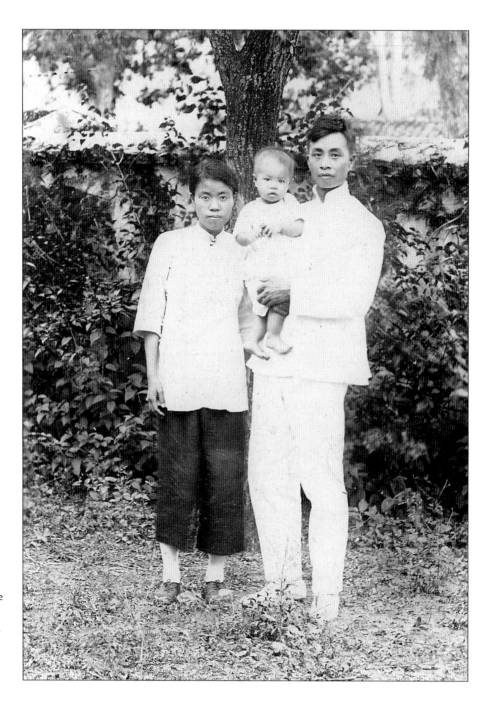

Reverend Shiu with his first wife
and their daughter, Quon Fong
Shiu (Elizabeth) in China, 1922.
Photo courtesy of Mark Low

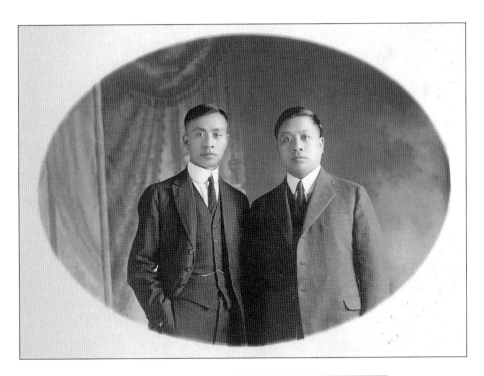

Reverend C.C. Shiu and his
older brother, C.Y. Shiu, c. 1930.
Photo courtesy of Mark Low

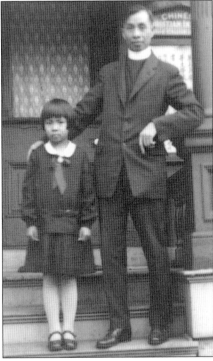

Reverend Shiu with his oldest
daughter, Elizabeth, outside the
church in Nanaimo, c. 1935.
Photo courtesy of Mark Law

When Pop came over, he came over as a United Church missionary from China to bring Christianity to most of the Chinese people that came to Canada, but in Chinese! He wouldn't speak English, but not to imply he could not . . . he just very seldom spoke English to us.

She [Julia Shiu] came out here with her uncle; [it] was a very close family as Mom used to speak of it often. It was a big family. Very poor. I think she came over in about 1905. My dad didn't come until 1924.

JOSHUA SHIU ~ REVEREND SHIU'S SON

The couple served various ministries across Canada: Winnipeg from 1924 to 1928, Hamilton from 1928 to 1930, and Montreal from 1931 to 1934. In 1934 the family returned to Nanaimo, where he became minister at the United Church at 905 Hecate Street.

In 1940, after 16 years of ministry, Shiu resigned from the United Church of Canada and moved his family to Vancouver. They stayed there for about a year, then moved to New Westminster. By this time they had eight children in tow: Elizabeth, who had come to Canada in 1929; Daniel, born in 1925; Esther, 1926; David, 1928; Samuel, 1931; Joseph, 1932; Solomon, 1935; and Joshua, 1939.

Although there is no evidence beyond personal recollections that Shiu came to New Westminster to teach Chinese at the Chinese Benevolent Association, it seems likely that he was asked to participate in the opening of the Chinese school, as he had years of experience teaching Chinese. How long Reverend Shiu worked at the school is unclear, but it is believed he remained there for only a few years. Leaving this venture behind, Shiu still stayed involved with the CBA, acting as its secretary for a time.

Despite having left the United Church years prior, the Reverend's faith had never waned. After the Second World War, and around the time he most likely finished with the New Westminster's Chinese school, Shiu went back to the ministry serving with Christ Church of China in Vancouver until 1970.

He was very forceful when he delivered his sermons. You didn't know what he was saying, but that wasn't a problem, everybody was paying attention.

MARTHA SHIU ~ REVEREND SHIU'S GRANDDAUGHTER/DANIEL SHIU'S DAUGHTER

Reverend Shiu held strong beliefs, and he endeavoured to instill that kind of faith in his children. He required them to study the Bible every night and encouraged them to join him on his street-corner excursions in Nanaimo, in which he preached and sang hymns with them.

Reverend Shiu wearing his clerical collar, c. 1935.

Photo courtesy of Margaret Shiu

Then we used to go up to Chinatown, it was all boardwalk, it was all dirt in those days. We used to go up there on the boardwalks. He [Reverend Shiu] took the wallpaper, turned it around [and] wrote words to all the hymns on the back. We'd carry that along. I'd be going up with him or Dave or both of us and we'd sit on a bench in front of the barbershop. It had one of these red-and-white candy-cane poles. That was one of the best places in Chinatown. Pop would start preaching when people walked by; we'd take the accordion out and we'd sing hymns. The reason we could do that there was because this barber had his eye on Liz, our older sister. This is how it worked. That was memorable.

SAMUEL SHIU ~ REVEREND SHIU'S SON

Ministering meant a lot of sacrifices for the Shiu family. The pay was not substantial and it required a lot of dedication. Raising a family of eight, C.C. and Julia had to be resourceful, saving money where they could and avoiding things that were too expensive.

I remember we had rations to buy stuff. Me and Mom used to go shopping. Mom was a really wondrous woman; she knew how to save money. She knew how to cut ends on everything and make everything go. She used to use old phone books as a potholder. Put the dirty pots on there and when it got dirty would rip off the page and burn it. Then there would be another fresh thing there to sit something on. We'd use it too for napkins.

JOSHUA SHIU

Three young Shius sitting on some steps. From left: Daniel, David and Esther, c. 1930.

Photo courtesy of Mark Low

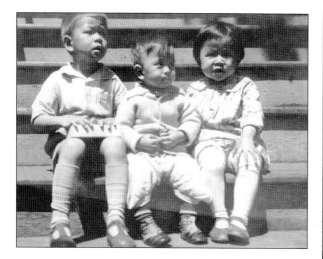

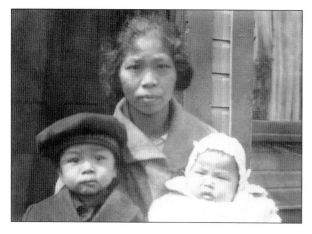

Julia Shiu holding her two children. Dan is on the left and Esther on the right. c. 1930s.

Photo courtesy Mark Low

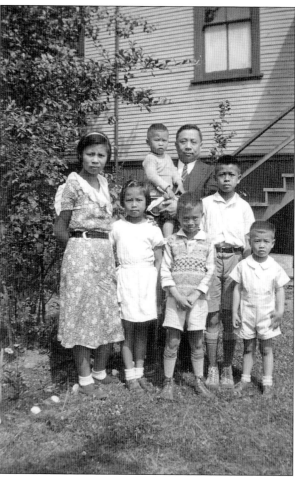

C.Y. Shiu visiting his brother's family, c. 1940. He is holding Joseph and standing next to Daniel. Front row, from left: Elizabeth, Esther, David and Samuel.

Photo courtesy of Mark Low

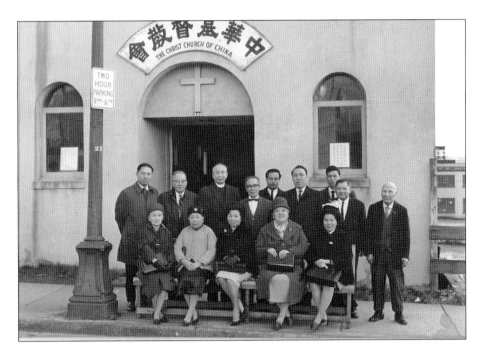

Reverend Shiu outside the Christ Church of China in Vancouver, c. 1960s.

Photo courtesy of Mark Low

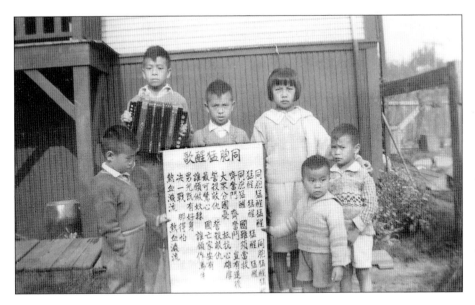

The Shiu children ready to preach on a street corner in Nanaimo, 1937. From left: Daniel, David, Esther and Joseph. Samuel and Solomon are holding the sign.

Photo courtesy of Mark Low

He [David] felt he had to help the family out during the Depression, so he wasn't always a good student. He didn't always go to school regularly; he would want to go out and earn money to help the family. So while the other boys were able to achieve higher education, he didn't. He was trying to figure out how to make money in other ways, rather than going to school.

DOROTHY SHIU ~ DAVID SHIU'S WIFE

Even without much money, the Shius found ways to help each other and make their own fun. Music and games brought the family together and at times helped them communicate with each other.

My dad played the accordion and could also play the piano. He had no lessons, he was just able to do that. He also played the Chinese harpsichord (yang quin), the bamboo flute, and the two-stringed viola pod, all by ear! He was also athletically inclined, a good diver and swimmer, and tennis player. He also did his own photographic developing. He had an illustrated book on tai chi. And of course, [he] gave free Chinese lessons to children, mainly to encourage religious attendance.

SAMUEL SHIU

Almost every member of the Shiu family played an instrument. Elizabeth, Esther, Samuel, Solomon, Joshua, C.C. and Julia all played the piano; Daniel played the trumpet, tuba and drums; David played the trumpet and trombone; and Solomon played the violin, guitar and flute. Joseph did not play an instrument, but he sang, as did everyone else. If the Shius were playing music, they were singing too. Joshua remembers how every Christmas someone would start playing the piano after dinner, and they would all join in singing. Music was something that always filled the Shiu home, a fact remembered even by visitors.

I remember my grandmother always humming. She would go about her chores with a melody always being hummed. I think she had a couple of favourite hymns, because it was always the same two tunes. What's funny is now I am always humming melodies without even knowing it.

NAOMI SHIU ~ REVEREND SHIU'S GRANDDAUGHTER/DAVID SHIU'S DAUGHTER

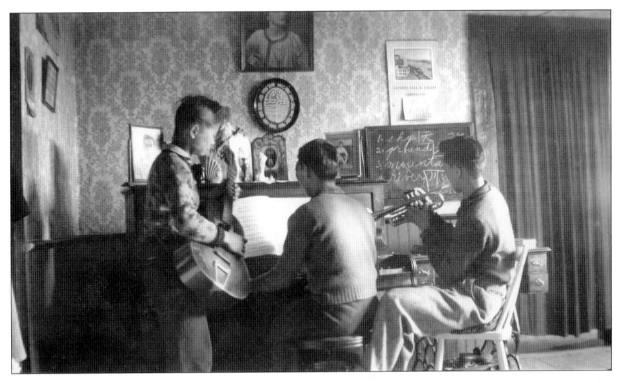

Music played an important role in the Shiu family and was part of everyone's life in one way or another. From left: Joseph on guitar, Samuel on piano and David playing trumpet at the family home at 513 St. George Street, New Westminster, c. 1940s.
Photo courtesy of Margaret Shiu

Reverend Shiu is playing a Chinese instrument called a *yang qin* as Julia looks on, c. 1970s. The instrument is played by hitting the strings with thin strips of bamboo.
Photo courtesy of Margaret Shiu

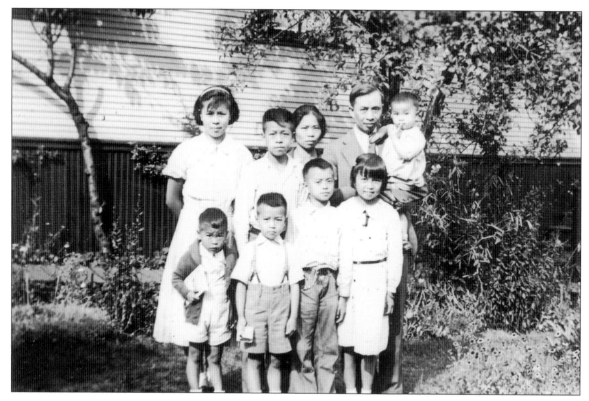

The Shiu family in their yard, c. 1935. Back row, from left: Elizabeth, Daniel, Julia and Reverend Shiu holding Solomon in his arms. Front row, from left: Joseph, Samuel, David and Esther.

Photo courtesy of Joseph Shiu

The Shiu children playing on the lawn in Nanaimo, c. 1930s. Back row, from left: Daniel, David, Esther and Elizabeth. Front row, from left: Samuel, Solomon and Joseph.

Photo courtesy Mark Low

Samuel, Solomon and Joshua took piano lessons outside of the home. For Samuel and Solomon, the lessons did not last long, but Joshua was able to study under New Westminster's renowned Miss Beatrice Cave-Brown-Cave. Joshua was a talented pianist who excelled at a young age, winning awards and recognition throughout his career. Other members of the Shiu family expressed their musical talents differently. Daniel sang for a brief period in a barbershop quartet. He also established church choirs when he was in the army and played in various marching bands.

Dan was about the only one that continued going to church. Everywhere we went he would start a choir. Even up in Inuvik, he had a choir. He was always very musical. After his retirement, he played the tuba in five different concert bands and parades.

MARGARET SHIU ~ REVEREND SHIU'S DAUGHTER-IN-LAW/DANIEL'S WIFE

Solomon was deeply involved in the arts, and at one point sang with the Vagabond Players, a local theatrical troupe. Many members of the Shiu family also sang in the Reverend's church choir.

Sometimes we went to the Chinese church. Grandpa use to play that instrument [the yang quin] in the church on special occasions, and sometimes he would want his granddaughter to sing along. He knew I didn't speak Chinese, so he would write it out phonetically for me and I would have to sing—with great embarrassment! Those were the moments I can remember. He was always very proud of me.

MARTHA SHIU

The Shius also shone at playing games, whether card games, Chinese checkers or chess. David and Joshua were astute chess players who won various local competitions. Chess was more than a game to them; it was part of their lives. Dorothy Shiu remembers her husband David playing chess by correspondence. He would write a move down on a postcard and ship it, with one cent in postage, to a competitor abroad. Needless to say, these matches were lengthy!

Daniel Shiu's children, Martha and Jonathan, saying their prayers at their home in the army camp in Ladner, c. 1958.
Photo courtesy of Joseph Shiu

Solomon playing with his niece, Julia, in the backyard, c. 1958.
Photo courtesy of Margaret Shiu

David loved to play chess. He could play chess blindfolded and simultaneously with two or three players.

DOROTHY SHIU

During tough economic times, money for entertainment was often scarce and people had to be creative. Like many other families, the Shius used the resources at hand to create a stimulating environment. Little wonder, then, that both the Reverend and his wife are remembered fondly.

Grandma took so much enjoyment out of playing Chinese checkers. My husband loves games too. That's how they communicated. Actually, all the boys like games.

DOROTHY SHIU

One of her favourite things to do was to crochet. She would make colourful doilies and little hats and gloves. She enjoyed playing the piano and would sit and listen to my playing. My grandmother taught me how to play Chinese checkers. We would sit at the kitchen table talking, playing and laughing.

NAOMI SHIU

He [Reverend Shiu] was very disciplined. He did his exercises every night, the same ones. He did these hand exercises. He used to often show me how he used to point each individual digit into the centre of his palm, one hand and then the other and then both together; then he'd stand up and do his feet exercises. He did those exercises every day of his life. He was in good shape even into his 90s.

MARTHA SHIU

I remember my grandmother with great fondness and sadness mixed together. She and I were very close, as I saw her every day from the time I was seven until she died, when I was 16. We lived on the same block as her, and so I went to visit her every afternoon after school was out. After being with her for two to three hours a day, I would head to my house for dinner. My grandmother and I would just sit and talk. She always asked me how my day was and she listened with an attentive

ear to all that I had to ramble on about. She was so loving, caring, giving, generous, kind, calm, patient, respectful—a true Christian.

NAOMI SHIU

I remember my grandfather as a tall, statuesque man in a wool cardigan with leather buttons, who, leaning down, would reach his hand out to me, saying something to which my response caused his smiling eyes to crease and cheeks to round. I used to love to run, and Grandpa would oblige me by chasing me through the rows of his vegetable garden. I have images of my grandfather and father in conversation, music coming from the piano and yang quin, calligraphy, reading, and Grandma in the kitchen cooking with my mother. Looking at the handful of photos I have of myself with my grandfather, he was always smiling—a true full happy smile.

SARAH SHIU ~ REVEREND SHIU'S GRANDDAUGHTER/SAMUEL SHIU'S DAUGHTER

The Shiu family at the Yu Chow Studio in Vancouver, c. 1940s. Back row, from left: Daniel, Elizabeth, Samuel, Esther, David. Front row, from left: Solomon, Reverend Shiu, Joshua, Julia and Joseph.

Photo courtesy of Mark Low

124

A gathering at 513 St. George Street, New Westminster, 1963. Shiu family cars line the street.
Photo courtesy of Margaret Shiu

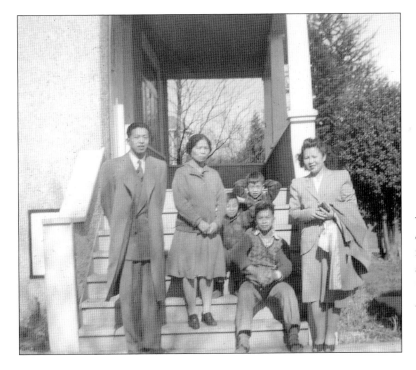

The Shius on the front porch of their house on St. George. Standing, from left: Daniel, Julia and Elizabeth. Seated, top to bottom: Joshua, Solomon and Joseph, c. 1950s.
Photo courtesy of Margaret Shiu

REMEMBERING Yi Fao

NEW WESTMINSTER'S CHINATOWN WAS A SMALL COMMUNITY WHERE people knew each other. They shopped at the same stores, went to the same schools and worked in the same businesses. In spite of the various day-to-day pressures they faced, members of the community found ways to stay unified. Three such ways—all of which involved the Law, Lee, Quan and Shiu families—were the establishment of the Chinese Benevolent Association (CBA) in the early years, and, later, the creation of a Chinese school and the founding of the Daughters of China.

The Chinese Benevolent Association provided a safe haven in the face of racism, ignorance and mistreatment. The association in New Westminster was created sometime between 1883 (the year the Victoria CBA was established) and 1887 (when the Vancouver CBA was formed). It played a pivotal role in New Westminster's Chinese community. In 1888 the CBA petitioned the City of New Westminster to grant the Chinese their own cemetery. In 1904 it opened a hospital at 826 Victoria Street, in a building that later became known as the Chinese Benevolent Association. It is believed that the hospital was used from 1904 to 1967 and was connected to an institution being used as an old-age home for men.

In 1915, New Westminster city council was pressuring the Chinese community to surrender the property it was using for its burial grounds. In response, the CBA formalized its operations, holding its first official meeting on March 16. Although individual attendees are not identified in the records of this gathering, there were representatives from eight businesses, including Kwong On Wo (the Lee family) and Ying, Tai (the Law family).

The building on Victoria Street was used not only as a hospital, but also as a community meeting room, a place for ceremonial events, housing and

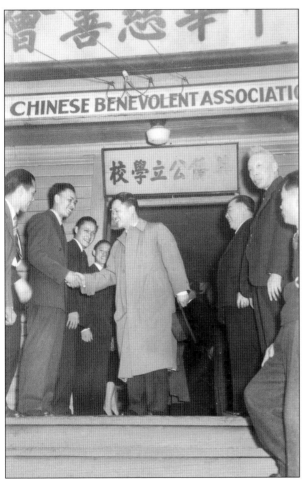

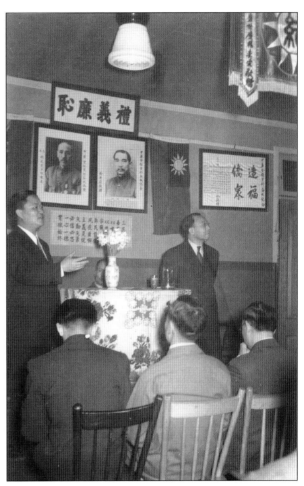

Chinese dignitaries and local
New Westminster businessmen
outside the Chinese Benevolent
Association, c. 1950s.

Photo courtesy of Lila Wing

Speeches being given inside the
local CBA, c. 1950s.

Photo courtesy of Lila Wing

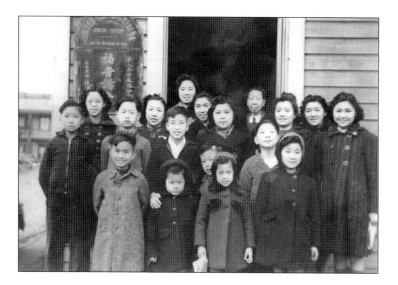

Sunday-school class was taught by Mrs. Eng Gwoo at the Chinese United Church. Bottom row, starting from the left: Dick Lee, Patsy Mark, Barbara Mark and Denise Quan. Middle row: Benny Quan, Ronald Law, George Quan, Kenny Mark (partially hidden) and Winston Quan. Back row: Jenny Quan, Kate Quan, Theda Law, Dora Law, Mrs. Eng Gwoo, Lily Lee, Betty Law and Gwen Quan. 1942.

Photo courtesy of George Quan

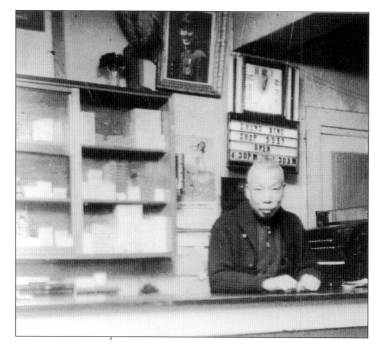

Charlie Wing inside the Chong King restaurant. Wing provided food for some of the events held at the CBA, c. 1940s.

Photo courtesy of Lila Wing

the Chinese school. More importantly, it was a place that united the Chinese community.

Fannie Lee remembers that in the early 1900s, the CBA was a meeting place where men could gather and discuss the various issues of the day. Later, during the 1940s, it opened up, becoming a social spot where men and women both could meet and share their ideas and stories.

The [Chinese Centre] used to be for special Chinese commemorative occasions. That's where the elder Chinese people would go and give speeches about whatever the occasion [was], and when we were little we used to go to these. They were boring as heck, but we used to go because the food was good! The food was so good! Charlie Wing—we used to call him Charlie Wing Bahk—owned a restaurant called the Chung King. He made the best sandwiches! Cha-siu sandwiches. They were so good.

It was a good place [the Chinese Benevolent Association]. It was wood. It was warm. It was a place you sat down; once you settled down, you did respect [it]. You had respect in there. There were pictures on the wall of senior gentlemen and Chiang Kai-shek. Along the walls there were also Chinese works of art, imaged tapestries and different things like that. I'm sure it was dirt [floor] downstairs. To the left of it, out by the basement door, just to the side of it, there used to be senior Chinese people that used to sell fish there.

BARBARA TUAI ~ LEE CHING'S GRANDDAUGHTER/FANNIE LEE'S DAUGHTER

The inside of the building was all wood construction. The basement was pretty well dirt; there was no concrete there. The upstairs had a fairly large gathering room that would hold about two hundred, maybe, at the most. Then, at the back, there would be a place for some washbasins, but there were rooms on the side. [He draws a map]. If this was the building, go up the front stairs and you go in the front door. Here we have the main gathering room [where] they had meetings. Then there's a little opening into a hall and there would be maybe six or seven rooms, bedrooms. Behind that there was a kitchen, the wash area and the storage area, where they had to store the food and the wood. There was about four or five people

that actually lived there permanently. They had some kind of arrangement, I never knew what that was.

GEORGE QUAN ~ QUAN HOY'S SON

I remember I used to go down there [to the CBA]. Apparently, we have an old picture of it somewhere. All the Chinese people were standing on the big stairs going up to the top. They took a photo of all of us. Everybody was in there, all of my family, all my brothers, all the other people. I remember the smell of it, old and musty . . . but it was a good smell. It's a smell I recognize in certain places in Chinatown if I go there.

JOSHUA SHIU ~ REVEREND SHIU'S SON

The CBA building played a large role in the biannual ancestor worship ritual, whereby families went to the cemetery to offer gifts and prayers to the dead. Those who took part in the ceremonies came back to the building to enjoy a feast.

I remember that every year they'd go up to the cemetery where the Chinese were buried. [They would] pack barbecued pig with them and all the other things they believed in. [It was] kind of a ceremony with joss sticks and candles. I think the older generation didn't much believe in that sort of thing, but they kept that up until maybe the Second World War. Every year they'd pack this barbecued pig up to the cemetery and offer it to whomever. They brought it back, cut the barbecued pig up [and] distributed it to the various Chinese who donated money.

CHONG (JOHN) QUAN ~ QUAN HOY'S SON

In 1942, through the desire and organization of local community members, the Chinese school opened in the CBA. Under the tutelage of first Reverend Shiu and later Tommy Ho, children were taught to speak and write proper Chinese, in hopes that the younger generation would retain their Chinese culture. The Chinese school ran until the late 1940s and then reopened in 1957 for a few more years.

A year before the Chinese school opened, the Daughers of China was formed. It was an organization created in response to the Second World War, and the women's strong desire to support the war in China resulted in numerous fundraising events. These efforts no doubt made the community feel more involved in the war than the Canadian government was letting them be.

At the onset of the Second World War, most Canadians, especially British Columbians, did not want Chinese-Canadians to be involved in the fighting. To them, allowing Chinese-Canadians to participate might lead to the Chinese obtaining the right to vote, something many people in BC opposed. Chinese-Canadians were also considered a security threat.

The feelings of British Columbians and the pressure coming from the province's legislature led to the cabinet war committee's deciding in October 1940 not to enlist Asians in military training. Before this, some Chinese had volunteered their services, but they had had to overcome stringent and often discriminatory regulations.

It wasn't until toward the end of the war, in the summer of 1944, that Pacific command headquarters received orders to call up the Chinese-Canadians in British Columbia. The change of heart stemmed partly from a shortage of able-bodied men, and there was also a growing desire to use Chinese-Canadians for specific ethnically related duties. For example, the British High Command needed recruits to work with Force 136, its Special Operations Executive (SOE) in Asia, to undertake sabotage and reconnaissance work behind enemy lines in Burma, Malaya and the Dutch East Indies. Suddenly, being Chinese and speaking a Chinese language were assets; eligible men could work alongside Chinese communist guerrillas and act as spies in Japanese-occupied territories.

Many Chinese boys from New Westminster enlisted for this service, including Daniel Shiu, John Quan and Lum and Kee Law. Not all of them made it behind enemy lines, but some, including Daniel, did see action. Daniel survived his tour of duty and continued to serve his country, remaining in the army and later joining the Royal Canadian Mounted Police.

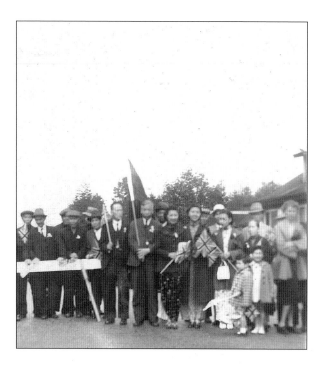

A crowd of Chinese-Canadians waiting to greet King George VI in 1939. From left, in front of the barrier: unidentified male holding a flag, Charlie Wing holding a flag, Jean Law, Quon Law, Sue Kong and Chow Shee (Law Soong's wife). The two children in front are Clarice (left) and Denise Quan, Betsey Quan's (née Law) children.

Photo courtesy of George Quan

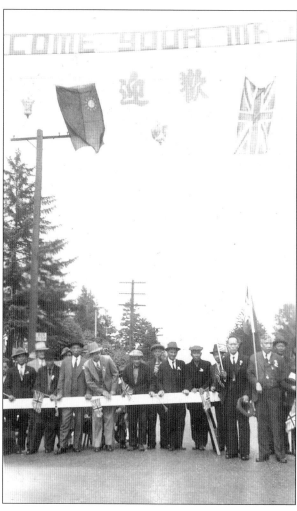

New Westminster's Chinese community erected a banner on Queens Avenue in 1939 to welcome King George VI.

Photo courtesy of George Quan

Mrs. See Quan and son Chong
(John) Quan before he left
home for the war front, 1944.
Photo courtesy of Chong Quan

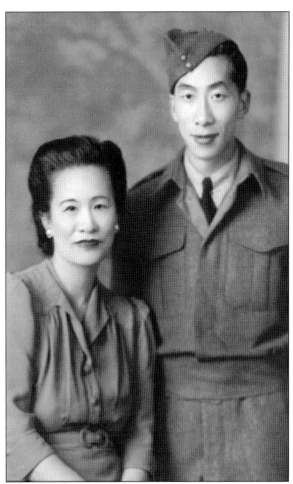

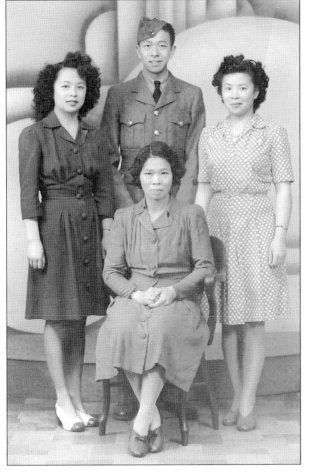

The Shiu women and Daniel,
c. 1940s. Elizabeth is on
Daniel's left, Esther on his right,
with Julia Shiu seated.
Yu Chow Studio in Vancouver.
Photo courtesy of Margaret Shiu

Dan joined the army in September of 1944, took basic training at Maple Creek. Then he went on the New Amsterdam troop ship to England, I think from Halifax. That's where he was joining the Force 136 and that's South East Asia Command (SEAC) under Lord Louis Mountbatten. That's why there's no records of a Chinese-Canadian war effort in Canada, because they were under the British.

The only reason why Canada allowed them [the British Army] to recruit over here for the Chinese-Canadians [was] so that they would blend in, because that was the time they were going over to fight the Japanese. After the war was over and he came back on this troop ship, he said they had six tiers of hammocks. People were seasick all over the place. It was terrible! Then when he came back, I guess he stayed in the army and he joined the Royal Canadian Corps Signals, RCCS. He was stationed up in Prince Rupert from 1947 to 1950. Prince Rupert used to be an army base too; the Americans were up there as well. That's where we met up, in Prince Rupert. Then I came down to Vancouver and we got married in 1950, then we moved into this Vancouver wireless station that's out at Ladner, but people nowadays claim there was never an army base there. That is where the Boundary Bay light-aircraft airport is.

MARGARET SHIU ~ DANIEL SHIU'S WIFE

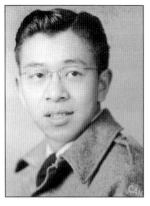

Daniel Shiu dressed in his army uniform before he was sent for training, c. 1940s.

Photo courtesy of Margaret Shiu

When the war came along, I was of eligible age for going into the services. I think I was the first Chinese-Canadian [in New Westminster] to be inducted into the army.

CHONG (JOHN) QUAN

After the war, Yi Fao altered drastically. Businesses closed and many families moved to Vancouver, causing the population to decline. It wasn't long before Chinatown was non-existent. With its demise, the need for the Chinese Benevolent Association diminished. In 1979, the last directors of the CBA, Park and Lily Wing, returned the land at 826 Victoria Street to the City of New Westminster as a gesture of thanks for having given the property tax-free status for many years. With this act, a chapter in New Westminster's history closed.

For those who lived in Chinatown, it was a place of community, where people banded together to support one another in the new country they had adopted. It was a place of familiar sounds and smells, where the Chinese felt at home.

Memories of Chinatown vary from family to family. Fannie Lee remembers a place more vibrant than the place familiar to her daughter's generation. Many long-time Chinese residents of the city do not remember Chinatown at all, as there has not been a Chinatown in New Westminster for many years. But one still exists within the memories of the Law, Lee, Quan and Shiu families.

I used to live on Columbia Street at the front of the store and [at] the back of the big property. There [were] quite a few stores. There was the Japanese fish store, I really remember the fish store because it was right next door. Then there were quite a lot of grocery stores along there, and vegetable stores—the whole block was all food.

FANNIE LEE ~ LEE CHING'S DAUGHTER

I used to ride the bicycle with the money and then bring [it] down to the rented house on Columbia Street, down to Queensborough, where all the men stay at Ying, Tai. Along Tenth Street or something, or Twelfth Street, I don't know. So long ago, I don't think I remember very much. I used to own a bike and I took the payroll down there, for the boys. I put money in an envelope to give to them, instead of cheques. I remember that. Riding a bicycle like a tomboy.

DORA CHAN ~ LAW SOONG'S DAUGHTER

It [Chinatown] was a sort of sad place because there were no Chinese women, mostly bachelors who worked in the mills and farms in all the area. They had the usual shops—the grocery store, thrift store. They were all sectioned on the one block on McInnes Street, pretty well. I don't know whatever happened to them. I guess through attrition and people moving away, they finally gave up the ghost. There's no Chinatown there anymore.

CHONG (JOHN) QUAN

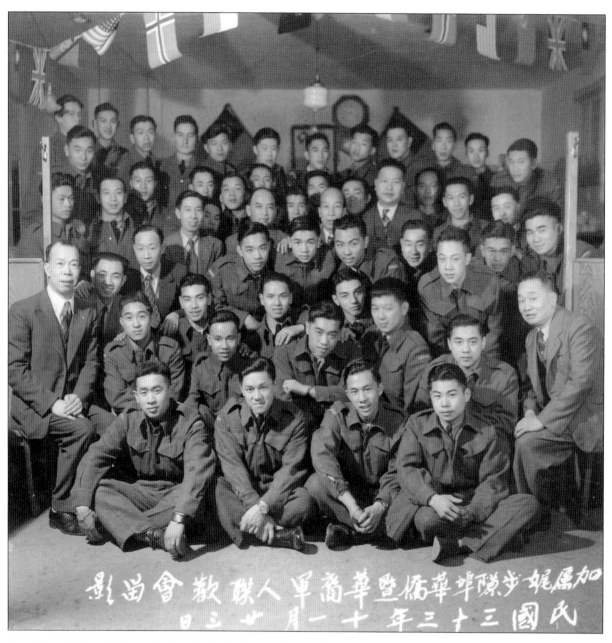

影留會歡聯人軍裔華暨僑華埠隊步妮屬加
日三廿月一十年三十三國民

One of Canada's three Chinese units that trained with Force 136 for special operations at Maple Creek, Saskatchewan. This photo was taken in Calgary, by local restaurant owners, before the regiment left for Ottawa in 1945. Back row, first on left: Kee Law; third from left is Daniel Shiu. Back row, third from right: Chong (John) Quan, who is standing to the right of Lum Law.

Photo courtesy of Mark Low

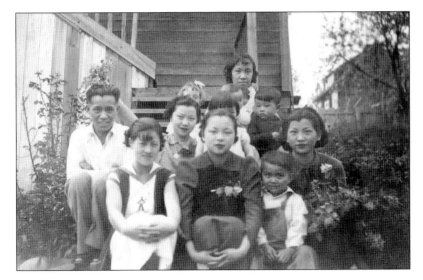

Sitting on the steps of Lee Ching's house, c. 1936. Front row, from left: Hannah Lee, unidentified female, Dick Lee. Second row, from left: Lin Lee, unidentified female, Barbara Tuai and Mary Wong. Third row, from left: neighbor Joyce Calquhoun, Pat (or Connie) Mark, Ken Mark. Back row: Fannie Lee.

Photo courtesy of Clifford Wong

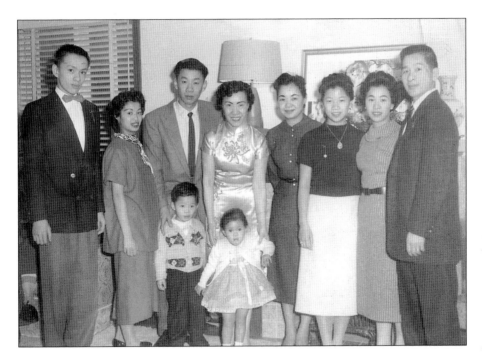

Fannie Lee's family. Back row, from left: Walter (Dedi) Mark, Donna Mark, Ken Mark, Fannie Lee, Pat Mark, Brenda Mark, Barbara Tuai (née Mark) and Kim Tuai. Front row, from left: Ken and Donna Mark's two children, Terry and Karen.

Photo courtesy of Fanny Lee

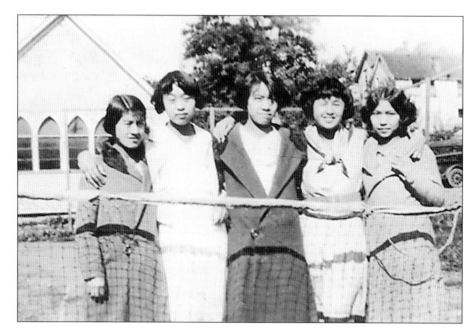

From left: Hannah Lee, Bessie Thom and Fannie Lee (the two other girls are unidentified) at the Tenth Street tennis courts in Chinatown, c. 1920s.

Photo courtesy of Fannie Lee

Boys will be boys: hanging around in Queens Park. On the top of the pyramid is Winston Quan, while Benny (left) and George are on the bottom, 1944.

Photo courtesy of George Quan

We got to know most of the Chinese families in New Westminster. There was sort of half a block around Tenth Street and Columbia that was the centre of Chinatown as we knew it then. There were maybe eight or nine stores there. Some were grocery stores. Some were selling meat and so on. There were quite a number of laundry places just off to the side of that street too. We had maybe 12 or 15 stores altogether; [that] was Chinatown.

GEORGE QUAN

Yee Wo was a grocery and vegetable store on [739] Columbia Street. I drove a delivery truck for them, a job my dad got me. I was thrilled to get the job because I loved to drive! However, one day I made a delivery to a business customer across town and as I was backing away in the parking lot, I clipped the back tail light cover off of a parked car. The tail light bulb itself was unharmed. Instead of stopping to go in to look for the owner, I went back to the store. That finished my delivery career, as the business customer phoned Yee Wo regarding a "hit and run"!

SAMUEL SHIU ~ REVEREND SHIU'S SON

Chinatown was not just a group of businesses or a geographical area: it was a community. Through their memories, these four families have recreated a time and place long neglected but not forgotten. Because of them, the history of New Westminster's Chinatown will never be lost.

Kind of sad, you know, when Chinatown gone. Everybody move away. Everybody used to be in Chinatown, a group of us.

FANNIE LEE

❧ BIBLIOGRAPHY ❧

Chan, Anthony B. *Gold Mountain: The Chinese in the New World*.
　　Vancouver: New Star Books, 1983.

Lai, David C. *Chinatowns: Towns Within Cities in Canada*.
　　Vancouver: The University of British Columbia Press, 1988.

Morton, James W. *In the Sea of Sterile Mountains: The Chinese in British Columbia*.
　　Vancouver: J.J Douglas Ltd., 1977.

Tan, Jin and Patricia Roy. *The Chinese in Canada*.
　　Ottawa: Canadian Historical Association, 1985.

Wickberg, Edgar, ed. *From China to Canada: A History of the Chinese Communities in*
　　Canada. Toronto: McClelland and Stewart Ltd., 1982.

Wolf, Jim. "Second Port City: An Overview of New Westminster's Chinese-Canadian
　　Community." *B.C. Historical News*, Vol. 1, No. 2, pps. 3–6, 12, Victoria, 1988.

Wolf, Jim. *Royal City: A Photographic History of New Westminster, 1858–1960*.
　　Surrey: Heritage House Publishing Co., 2005.

Yee, Paul. *Saltwater City: An Illustrated History of the Chinese in Vancouver*.
　　Vancouver: Douglas & McIntyre, 1988.

❧ PHOTO CREDITS ❧

The following abbreviations were used in this book.

IHP: Irving House Photo—New Westminster Museum and Archives

NWPL: New Westminster Public Library

❧ JIM WOLF ❧

Jim Wolf is the heritage planner for the City of Burnaby, BC, and is an active heritage consultant and well-known historian. A long-time resident of New Westminster, he has been actively committed for more than 20 years to preserving the city's heritage. He is the author of *Royal City: A Photographic History of New Westminster 1858–1960* (Heritage House, 2005).

❧ PATRICIA OWEN ❧

Patricia Owen completed a master's degree in the arts of Africa, Oceania and the Americas at the University of East Anglia, United Kingdom, in 2005. She took a lead role in the New Westminster Museum and Archives' project to research the city's Chinese-Canadian community. She is currently on a contract with the Museum of Anthropology at the University of British Columbia in Vancouver.